WATERCOLOR

AN ARTIST'S GUIDE TO PAINTING ON THE GO!

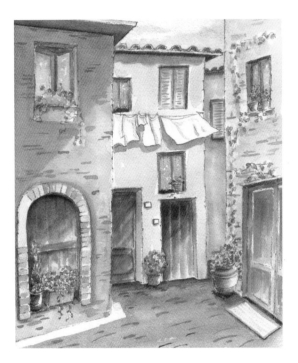

Barbara Roth

Brimming with creative inspiration, how-to projects, and useful information to enrich your everyday life, Quarto Knows is a favorite destination for those pursuing their interests and passions. Visit our site and dig deeper with our books into your area of interest: Quarto Creates, Quarto Cooks, Quarto Homes, Quarto Lives, Quarto Drives, Quarto Explores, Quarto Gifts, or Quarto Kids.

First Published in 2017 by Walter Foster Publishing, an imprint of The Quarto Group. 6 Orchard Road, Suite 100, Lake Forest, CA 92630, USA.
T (949) 380-7510 **F** (949) 380-7575 **www.QuartoKnows.com**

Walter Foster Publishing titles are also available at discount for retail, wholesale, promotional, and bulk purchase. For details, contact the Special Sales Manager by email at specialsales@quarto.com or by mail at The Quarto Group, Attn: Special Sales Manager, 401 Second Avenue North, Suite 310, Minneapolis, MN 55401 USA.

ISBN: 978-1-63322-195-6

Design: Erin Fahringer
Project Editor: Lindsay Hathaway

Printed in China
5 7 9 10 8 6 4

Table of Contents

Introduction

What if I said you could learn a skill that would help you reduce stress, better observe the world around you, find joy, *and* increase your appreciation for the colors, shades, and textures that surround you?

It's easier than you think! I've watched tons of students learn to do it over the years. And you can too.

This skill is making anywhere, anytime art. It's the ability to grab a pencil, pen, or brush and draw any image that captures your interest. I've had countless students succeed, even those who believed they had no artistic abilities or hadn't picked up a paintbrush since kindergarten.

But even after you've learned technique, the struggle to make art still remains. We're usually left trying to find time for artistry in the midst of our to-do lists, which got me thinking about making art creation more accessible.

My own obsession with making anywhere, anytime art has developed over the last 20 years. I've loved painting since I was a little girl, but as I grew older, so did the demands on my personal time. I soon struggled with finding the time to draw and paint for myself.

My difficulties were nothing new, and I began to listen to many of my students' ongoing frustrations with finding the time to fit art creation into their own busy lives. After talking about their personal struggles to make art outside of class, I came up with some ideas for solving this problem and tested many strategies, tools, and pieces of equipment. The results of those findings are the inspiration for this book.

WHAT YOU WILL LEARN

Within these pages, you will learn how to paint and sketch in a short period of time. Best of all, you'll learn to do it wherever and whenever you want with a relaxed attitude, even when the results aren't perfect. No matter your creative roadblocks, this book can help.

- **Where should I set up to make art?** Learn to set up a portable art studio in your home or wherever you want to create.

- **My time is limited. How long will this take?** Get the materials to assemble your "Anywhere Art Bag" and working space, and start creating art within 10 minutes.

- **My drawing and painting skills are weak at best. Can you help me improve?** Yes! If you put in the practice, I'll provide the easy-to-understand basic painting and sketching instructions and tips. The step-by-step paintings in this book are specifically crafted to help you develop your skills and gain confidence in your artistic abilities.

- **How can I make something great every time I sit down to paint?** You can't. Drawing and painting are like learning a new language. You might fumble over a few areas here and there, but with time and practice, you'll be fluent before you know it.

- **Art stores are overwhelming. Which supplies should I use?** Learn the necessary tools and equipment to ease your creative process. Then explore the shop aisles to assemble your own supply stash, or try some earth-friendly ways to make art supplies out of recycled and repurposed items.

- **I hate being cooped up at home. Can I paint and draw outside my house?** Pre-planning is your friend. Figure out what supplies you need to create quickly and efficiently in the location and timeframe that work for you.

- **How can I find a subject worth committing to art?** Develop your artistic eye, and learn how to find a quality image anywhere.

- **I don't have any grand travel plans in the near future. Do I have to be in an exotic location to make art?** Of course not! Find something worthwhile to draw and paint wherever you are. Inspiration is everywhere, just waiting to be discovered.

Welcome to making art anywhere and at any time. If you struggle with finding the ability to make art more often, this book is for you. Sit down, grab your favorite drink, and get ready to unleash the artist within.

Tools & Materials

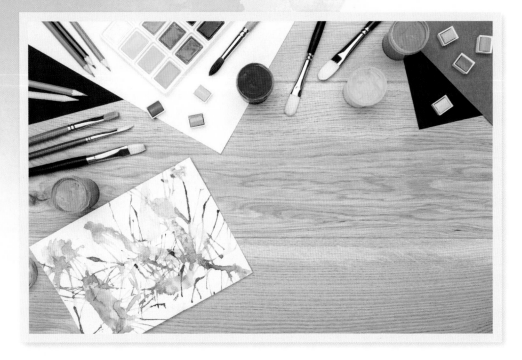

SET YOUR SPACE

If you have the room for it, set up a desk as your main area to work from and store your materials on an ongoing basis. It doesn't need to be a new or fancy setup, just a comfortable height where you can work. Mine's an old drafting tabletop set atop two trestle stands. Once you've set up your space, keep the area bright—so you can see colors accurately—using a desk lamp and full-spectrum light bulb.

No room for a desk? A large tray will do in a pinch. Just make sure it's big enough to fit your art supplies and carry around wherever you paint. And if you're *really* on the go, try a wooden box that will fit on your lap for painting in the passenger seat of a car.

THE ESSENTIALS

I recommend using a journal for your ongoing (and on-the-go) art as opposed to carrying pieces of loose-leaf paper. It's easier to contain, and you can flip through for a sense of accomplishment as your skills grow. You can buy preassembled water-color journals, or make your own. I prefer a stitched binding to spiral coils, because the coils are bulky and difficult to work with when

trying to draw a landscape across a spread. While in the paper section of your art-supply store, also pick up some graphite paper for tracing.

I LIKE MOLESKINE JOURNALS. THE PAPER IS EXCELLENT FOR WATERCOLOR PAINTING, AND THE PAGES ARE TIGHTLY STITCHED. DEPENDING ON HOW MUCH ROOM AND TIME I HAVE FOR PAINTING, MY FAVORITE JOURNAL SIZES TO WORK WITH ARE 3"X5", 8"X5", AND 8"X11".

Start with at least 1 paint palette, and build out your collection as needed from there. I suggest keeping 3 different-sized palettes on hand to use depending on where you go to paint. For painting in restaurants, bars, airplanes, or other places with limited space, I converted a mint tin into a small-sized palette filled with watercolor paint. For slightly larger spaces, I use a 2½" x 3½" pocket-sized palette made from a bigger mint tin.

Artist-quality paints provide more color and less filler. But student-quality paints work too if you're on a budget or just starting out. I prefer to buy my watercolor paint in tubes and squeeze them into the pans in my palettes.

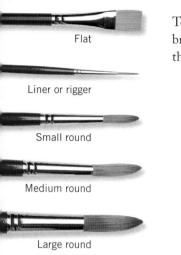

Flat

Liner or rigger

Small round

Medium round

Large round

To achieve variety in your brushstrokes, you'll need an assortment of brushes. Keep different of brush types and sizes on hand. I suggest the following:

- Rigger or liner brush
- ½" square brush
- Size 5 standard-size round white sable paintbrush
- Size 6 round brush
- Size 10 round brush

MY FAVORITE BRUSHES HAVE VERY SHORT HANDLES SO THAT THEY CAN EASILY FIT INTO SMALL SPACES. I DON'T BELIEVE YOU NEED TO SPEND A LOT ON BRUSHES TO GET GOOD RESULTS. SYNTHETIC BRUSHES IN THE $5 TO $15 RANGE PAINT WELL.

COLOR PALETTE

I occasionally branch out in my color choices, but the ones I most often prefer to keep in my palette are:

- burnt sienna
- cerulean blue
- cobalt blue
- dioxazine purple (or carbazole violet)
- lemon yellow
- new gamboge (mustard yellow)
- permanent red (lipstick red)
- permanent rose
- quinacridone magenta
- sap green
- scarlet lake (red-orange)
- phthalo blue
- ultramarine blue
- yellow ochre

Your primary sketching pencils will be 2B. If you prefer a darker line that you can smudge for shading, I recommend using 4B or 6B pencils. Water-soluble graphite pencils in medium or dark are handy for quick shading by brushing water over the pencil line. I also suggest using a blending stump to shade by rubbing it along the pencil lines.

When you have enough room to bring them along, watercolor pencils are ideal for drawing in a hurry. You can brush water on them later, and they almost look like paint. I usually bring them on the go in an assortment of colors.

I LIKE TO DRAW WITH #2 HB PENCILS, AND I ALSO KEEP A .07 MECHANICAL PENCIL ON ME. THE WHITE ERASER DOESN'T SMUDGE WATERCOLOR PAPER, AND I NEVER HAVE TO WORRY ABOUT SHARPENING.

UTILITY & UTENSILS

Carry your tools in a sturdy zippered bag. Choose a portable size that allows you to grab your tools and go out and sketch at a moment's notice. Cosmetic bags are a good size and usually waterproof, which is ideal in case of spills.

Carry your brushes on the go in a roll-up brush holder to keep the tips from getting damaged. You can easily make one out of a piece of felt or a placemat.

For sharpening large and small pencils, get a multi-size sharpener with a barrel to collect the shavings. This will especially come in hand if you sketch somewhere without access to a trash can. My favorite sharpener fits on top of my pencil.

Another sketching must-have is a good eraser. I prefer the kneaded or soft white kinds, because they don't ruff up or smudge my paper like those pink ones typically found on pencils.

Pens aren't necessary, but I like having the option to use one if I want a harder, darker line in my artwork. Just make sure they're waterproof. I like using sepia and sanguine (dark reddish-brown) ink in most of my art, but you may prefer black.

I KEEP MY PENS, PENCILS, AND TRAVEL BRUSHES IN THE POCKETS OF A 5"X6½" CANVAS FABRIC FOLDER THAT FITS PERFECTLY INTO MY ART-SUPPLY BAG. IT KEEPS ME ORGANIZED SO I DON'T LOSE ANY EQUIPMENT.

EXTRA SUPPLIES FOR FINISHING TOUCHES

- White crayon or piece of wax for the wave foam in ocean paintings
- White magic-erasing sponge for erasing paint mistakes
- Toilet paper ("artist's tissue") or facial tissue for dabbing to absorb excess water and paint
- Pen filled with masking fluid to preserve the paper and draw thin white lines
- Binder clips for holding your journal pages open and for clipping your palette to the edge of your journal
- Viewfinder for finding and framing your painting subjects
- Value finder for ensuring that you've included enough values in your painting
- Angle finder for measuring angles

Bring along a folding or stacking water container if you like, but you can usually find a paper cup and some water, so I consider this optional.

Place all of these supplies in a messenger bag or tote, and you're set to paint anywhere, anytime.

IF YOU FIND A SUBJECT OUTSIDE WITH NOWHERE NEARBY TO SIT, A SMALL FOLDING STOOL OR CHAIR IS HELPFUL, BUT IT'S CERTAINLY NOT NECESSARY. WHEN I TRAVEL, THERE USUALLY ISN'T ENOUGH ROOM IN MY SUITCASE FOR MY CHAIR, SO I BRING ALONG AN OLD MESSENGER BAG TO FOLD UP AND SIT ON. I CAN USUALLY FIND A SEAT SOMEWHERE WITH A VIEW I WANT TO PAINT.

Anyone Can Draw

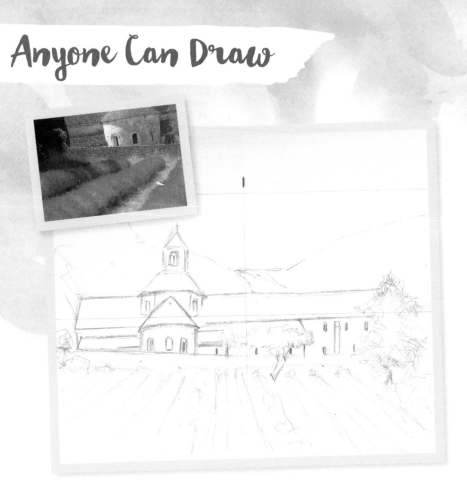

Learning to draw isn't a special skill that only artistic people are born with, and it's not as difficult as you might think. After many years of studying drawing books and teaching classes, I've discovered that drawing comes down to a handful of necessary skills and practicing them. So grab some paper, a pencil, and an eraser, and start now.

USING PHOTOGRAPHIC INSPIRATION

You may find that working from a photographic image is easier when you're just starting out, since you don't have to battle varying weather conditions. Further simplify the drawing process by folding your photo into quarters, and loosely sketch one section at a time.

It's all about breaking an image down to its most basic shapes. See how I applied these concepts to a drawing of an old French abbey (for painting instructions, see "Watercolor Made Simple" on page 18).

STEP 1

Divide your paper into quarters, lightly drawing a vertical and a horizontal line, and sketch a section at a time, moving your pencil quickly in what's called a "gesture drawing technique."

Then open up your folded photo, and compare it to your drawing. Add any necessary additional lines or shapes in your sketch.

STEP 2

If something is slightly off but the overall drawing looks fine, don't worry about it being perfect. If your drawing doesn't look right, check the proportions using a unit of measurement.

My unit of measurement for this drawing was the width of the front rounded building, which I compared to the height of the little building from its base to the conical tip as well as other parts of the scene. I adjusted the size of the drawing by holding my unit of measurement up to the drawing and figuring out the sizes of other parts of the building.

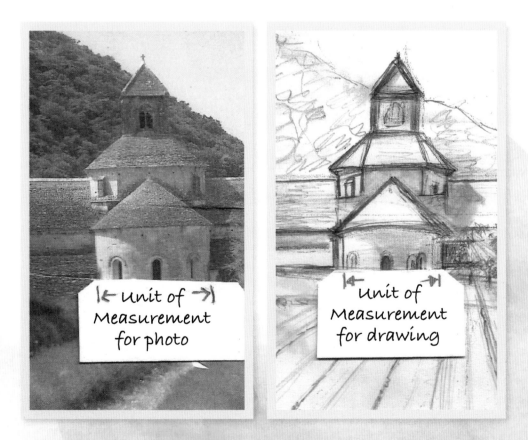

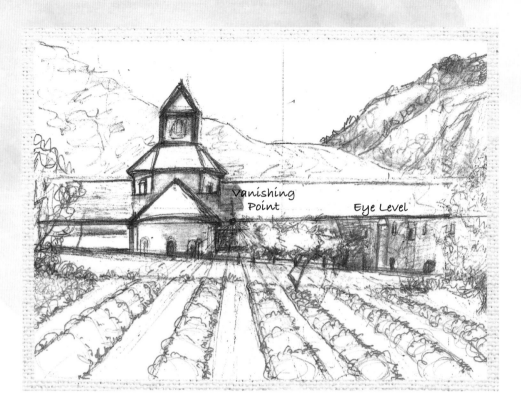

STEP 3

Add some simple shading to better define the shapes, smudging with a blending stump. Then find where the eye looked directly straight ahead when taking the photo. This is called the "eye level" and will help determine a one-point perspective and the vanishing point for any smaller, distant elements, such as the lavender plants in my sketch.

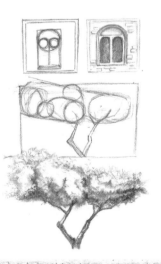

STEP 4

Determine the biggest shape beneath each detailed image. It may be a rectangle, like the foliage of the tree in front of the abbey. To add further detail, like the curved shape of the tree foliage, draw several small circles and ovals. Pay attention to detail. The top of the tree is on a slant, so sketch a slanted top on the large rectangle, then draw around the outside of the shapes to form the general outline of the treetop. Draw all of your basic shapes.

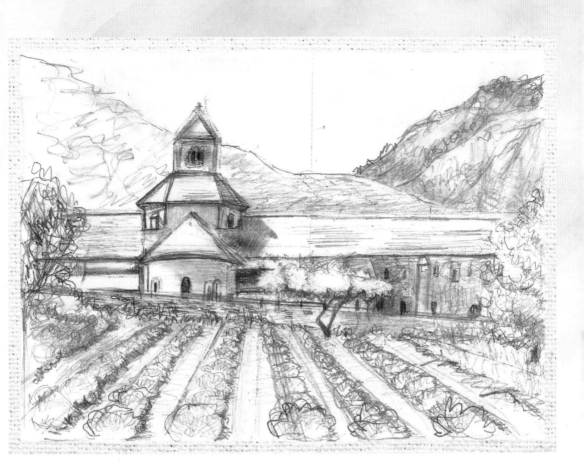

STEP 5

Add details by slowly moving your pencil on the paper as your eye follows the object. Sketching without looking at the paper may feel awkward at first, but practice makes close to perfect. Glance at your drawing only when changing line direction or if you sense you're veering off.

Then finalize your sketch, squinting at the photo to focus on the values of light, medium, dark, and very dark for any shading needs. Step back to assess your drawing, and adjust anything that looks off.

DRAWING FROM EXPERIENCE

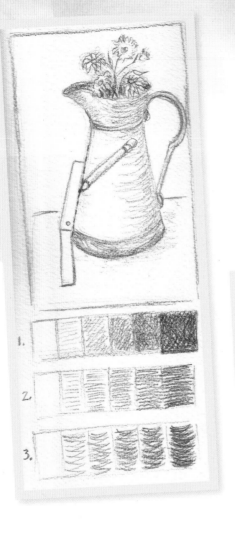

Very few people can draw perfectly without a point of reference. I find most of my own drawing subjects in my surrounding environment and in photographs. Over time, you'll train your eye to look for art subjects around you.

This can initially be confusing because you see so much at once, but you can easily make two tools at home to help narrow your search: a viewfinder and an angle finder.

DIY VIEWFINDER

Make a viewfinder by cutting a square in the center of an index card or repurposing an empty slide mount, and look through it to frame your view—like looking through the lens of your camera to find a picture.

DIY ANGLE FINDER

Take two ¾" strips of cardboard (an empty cereal box is handy), and punch a hole at both ends, connecting with a brad. Use this DIY angle finder when trying to draw anything at an angle by holding one strip at a 90-degree vertical and adjusting the other to the angle you see. Carefully lay down the slanted strip on your paper to trace the line along the slant on your paper and quickly achieve perspective. Then sketch your chosen scene.

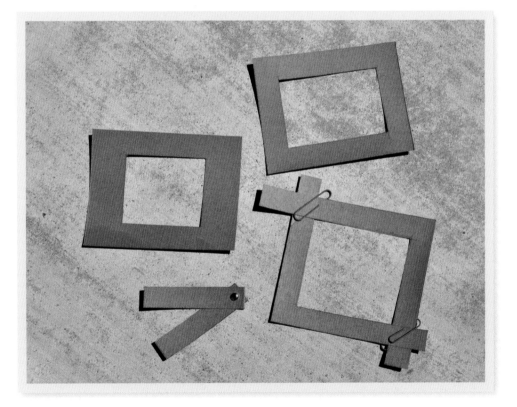

WHEN YOUR FINALIZED SKETCH IS DONE, YOU CAN EITHER LEAVE IT OR DECIDE TO ADD PAINT. IF YOU WANT TO ADD PAINT, THE NEXT STEP IS TO COPY, TRACE, OR DRAW THE SAME SKETCH ONTO WATERCOLOR PAPER.

Watercolor Made Simple

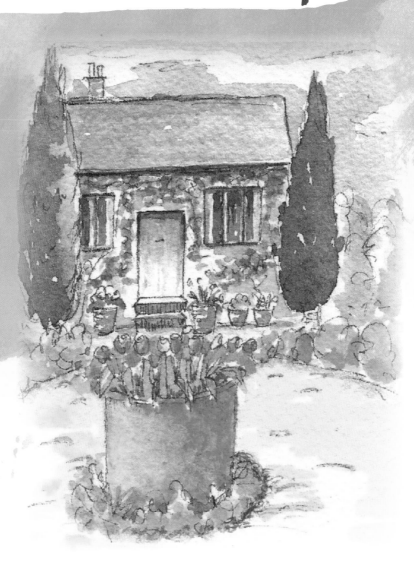

Watercolor painting is all about the amounts of water and paint used. It can be a little difficult to control until you learn a few techniques. But if you're willing to practice and play with your colors, you'll learn a very portable method of painting.

You can achieve a variety of looks using a multitude of techniques. I prefer the following:

PAINTING TECHNIQUES PICTURED

Flat Wash

Graded Wash

Wet-into-Wet

Color-into-Color

Wet-on-Dry Paint

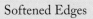

Softened Edges

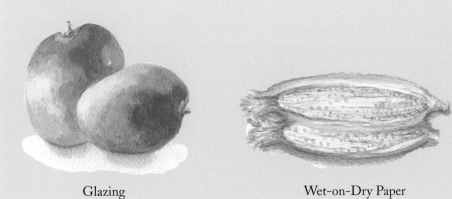

Glazing

Wet-on-Dry Paper

BASIC PAINTING TECHNIQUES EXPLAINED

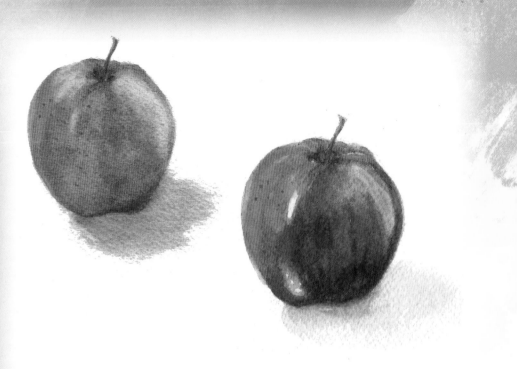

Flat wash: Prop up watercolor paper on a support board, and dip your brush in a puddle of paint. Then touch it to the paper, guiding the paint in a horizontal direction as it forms a small bead of paint. Gently nudge the bead along in a horizontal stroke. When the bead is almost gone, reload your brush with paint, and touch it to the spot where the bead disappeared. Continue replacing the bead where it disappears to avoid forming a line as the paint dries.

Graded wash: Create a lighter color effect down the page by filling the brush with water instead of paint. More water is added with each stroke, so the color fades gradually as you work your way down.

Wet-into-wet: For a liquid-looking wash on subjects like skies, bodies of water, and large flower petals, spread clean water on your paper with a clean brush, and then dip a soupy puddle of paint into the wet area.

Color-into-color: Place two colors close enough to touch and mix together.

Wet-on-dry paint: Add new paint onto a layer of dried paint.

Softened edges: Blend an additional layer or soften an edge using a damp brush, and wiggle it parallel to the hard edge until the paint blurs. A slightly stiffer brush works well for this.

Glazing: Layer watery washes on top of each other. Each wash must be completely dry before you add another so that the colors don't mix. This builds depth and can result in a luminous effect.

Wet-on-dry paper: Apply wet paint onto dry paper for the most control over your paint and crisper edges.

FIXING MISTAKES: MISTAKES ARE PART OF THE PAINTING PROCESS, BUT HERE ARE A FEW WAYS TO FIX THEM:

- PAINT CLEAN WATER OVER THE MISTAKE, AND DAB IT WITH A TISSUE TO LIFT OFF THE PAINT.
- RUB THE PAINT OFF WITH A WET ERASER CLEANING SPONGE, THEN DAB AND REPEAT IF NECESSARY.
- USE A DAMP, STIFF BRUSH (A SCRUBBER) TO LIFT OFF THE PAINT, BUT BE GENTLE TO AVOID RUINING YOUR PAPER.

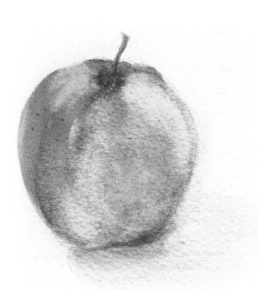

ADDING COLOR

Using the finished drawing from page 15 as an example, here are some basic watercolor techniques to turn a pencil drawing into a colorful painting.

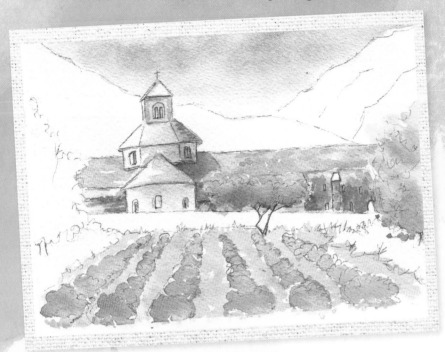

STEP 1

Brush a little water across the sky area above the mountains. Then mix a puddle of cerulean blue, touching the brush to the wet sky area and letting the blue float across the sky. While still very wet, add more blue paint at the top.

STEP 2

Next, paint the lavender rows with a mixture of permanent rose and ultramarine blue. (If you paint the mountains while the sky is still wet, the colors will bleed into each other, which may not be your desired outcome.) Use the wet-into-wet technique for the lavender, trees, and building.

STEP 3

Let the trees dry before painting the abbey with a mix of cerulean blue, yellow ochre, and a touch of violet. Then use blue and violet to add darker blue strokes to the building when the first layer of paint is dry.

STEP 4

Using the wet-on-dry technique, add strokes of burnt sienna and yellow ochre in front of the fence, under the tree, and between the rows of lavender. Then mix some permanent magenta with yellow ochre to paint the roof when the front of the building is dry.

STEP 5

Combine a dull mixture of sap green, violet, and cerulean blue for one side of the mountains, brushing differing amounts of color-into-color, letting them mix on the paper. For the mountain on the right, use a mix of ultramarine blue and burnt sienna.

STEP 6

Brush clean water on the first row of lavender plants, floating in a bright layer of color to add atmospheric perspective. Let the layer dry, and then add details with darker paint. Add a few more details wet-on-dry, and then look at the painting from a distance to assess the overall look. You might want to add a few smaller details.

TIP: LIGHTLY TOUCH THE PAINT WITH YOUR FINGER TO TELL IF IT'S DRY. IN A HURRY? USE A HAIR DRYER TO SPEED UP THE DRYING PROCESS.

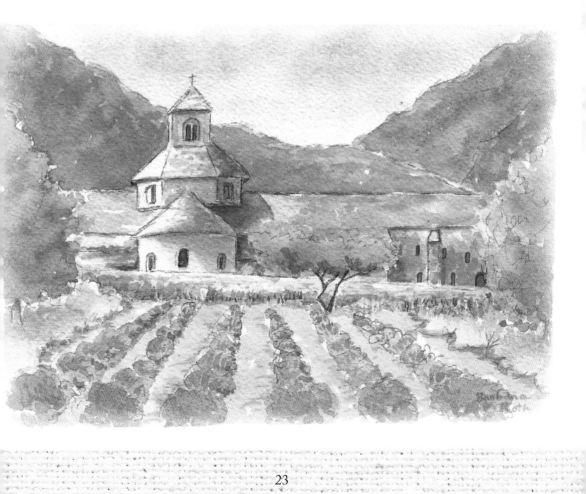

Lessons in Color Theory

Like numbers on a clock, there are 12 colors on the color wheel. Knowing this can help you remember the colors. Color mixing also becomes much easier when you know a little about how it works. When painting, keep a color wheel handy.

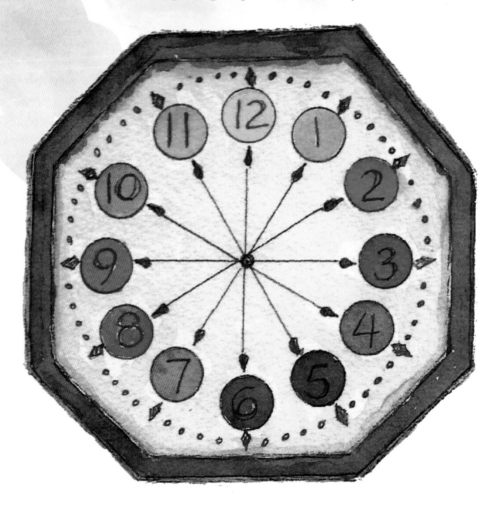

THE COLOR WHEEL

Getting to know the color wheel will help you understand color relationships. Knowing where colors lie in relation to each other can help you group harmonious and contrasting colors, which can be used to communicate a certain mood or message.

COLOR TERMS

The primary colors are red, blue, and yellow. These can be mixed to create any other color, but the other colors cannot be mixed to create primaries. Secondary colors are green, orange, and violet. Two of the primaries can be mixed to create secondary colors. For example, blue and yellow make green, and red and yellow make orange. Tertiary colors, such as red-orange and blue-green, are created from a mixture of a primary and a secondary color.

A hue is the color itself, intensity means the strength of a color, and value is the relative lightness or darkness of a color.

Exercise

Try filling in a blank color wheel with the watercolors in your own palette, keeping in mind what you just learned about the color wheel.

COMPLEMENTARY & ANALOGOUS COLORS

Colors opposite each other on the wheel are called "complements." If you mix a color with its complement, they dull each other in varying degrees, depending on the amount of each color in the mix. Equal amounts produce a neutralized color.

Neighboring colors, called "analogous," generally mix well without becoming dull. Brighten a color by mixing in a brighter neighbor, or combine some of a darker neighbor to darken a color.

DON'T FEAR MUDDY COLORS, IT'S IMPORTANT TO KNOW HOW TO DULL A COLOR OR CREATE A NEUTRAL, ESPECIALLY FOR LANDSCAPES.

Barbara Roth

COLOR TEMPERATURES

To determine if a color is warm or cool, think of sunshine versus the ocean and the sky. Yellow, orange, and red are warm shades, while cool colors span blues and greens. Color temperatures are relative, depending on their color surroundings. Warm colors appear to come forward in a painting, and cool colors appear to recede.

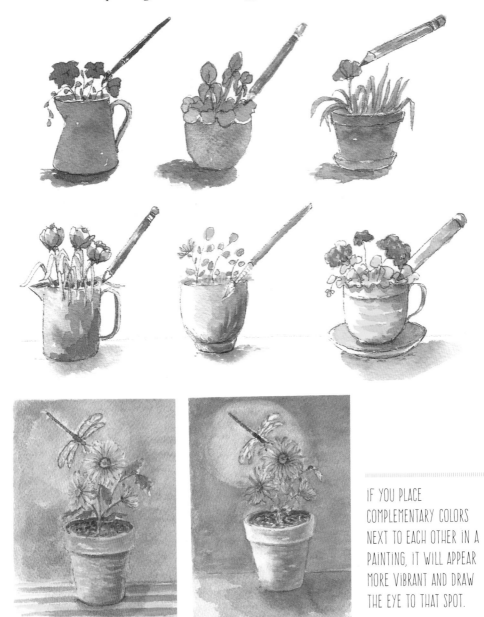

IF YOU PLACE COMPLEMENTARY COLORS NEXT TO EACH OTHER IN A PAINTING, IT WILL APPEAR MORE VIBRANT AND DRAW THE EYE TO THAT SPOT.

Making Art on the Go

Making art on the go doesn't require fancy equipment and years of art training. You just need to keep your eyes open, avoid being easily embarrassed, and be able to tolerate less than perfection in your paintings and sketches.

It's not about creating masterpieces; it's about looking closely and responding to what you see around you. It's about recording memories or moments in time to recall later and savor again. It's about seeing colors, shapes, and shadows that you never noticed before. It's about what is important to you—committing to memory what interests you and what you can find wherever you are.

And most of all, to make art on the go, you need to be able to locate your art supplies quickly. They need to be portable, durable, and packed in a simple bag to take with you wherever you go.

MOBILE MEDIUMS: BECAUSE THE SUPPLIES ARE LIGHT AND MINIMAL, AND SINCE ITS PAINTINGS DRY QUICKLY, WATERCOLOR IS AN OBVIOUS MEDIUM OF CHOICE FOR ARTISTS ON THE GO. IT'S NOT THE ONLY EASILY TRANSPORTABLE ART MEDIUM, HOWEVER. CRAYONS, MARKERS, GOUACHE, PENCILS, PENS, PASTELS, AND OIL PAINTS ARE ALL PORTABLE AND GREAT OPTIONS FOR CREATING ART WHILE OUT AND ABOUT. WHAT IS YOUR FAVORITE MEDIUM FOR ON-THE-GO CREATIVITY?

FINDING A LOCATION AT HOME

Your home art nook should ideally allow you to leave your supplies out so you don't waste time finding and setting up your stuff when you find a free moment. Create your art spot somewhere close to where you spend most of your time so you can easily dash over to paint. If you have to climb the stairs to get to your attic studio, chances are you won't find much time to paint.

I'VE ONLY RECENTLY CREATED A DEDICATED ART ROOM. FOR MANY YEARS, I PAINTED FROM A DRAFTING TABLE IN MY BEDROOM OR FOUND SOMEWHERE TO PAINT WHENEVER THE KIDS WERE PLAYING. NOW, MY HOME STUDIO IS IN A LITTLE ROOM NEAR MY KITCHEN, WHERE I WANDER OVER TO WORK WHENEVER I'M WAITING FOR SOMETHING TO BAKE OR WATER TO BOIL. BUT I DON'T ALWAYS DRAW IN MY STUDIO. OFTEN, I ROAM AROUND MY HOUSE FINDING INTERESTING THINGS TO PAINT. MY FAVORITE IS TO CHECK IN ON MY DOG LOUNGING IN THE LIVING ROOM.

Look for a spot in your house with room to open your sketchbook and set out your supplies, such as a counter, small desk, shelf, or card table. You'll also need a desk lamp with a full-spectrum light bulb for seeing colors accurately. If you want to paint in bed, invest in a bed tray to hold your supplies.

Don't set your supplies on your kitchen table. If you use the table for meals, you'll constantly have to put away your supplies to eat, and then take them back out. It'll become tedious and discourage you from painting.

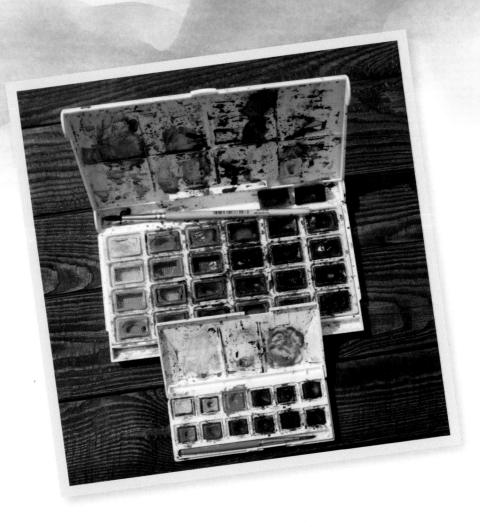

CREATING A PORTABLE STUDIO

You'll find more subjects to paint when you leave your house. If you keep everything together in one portable container—such as a tray, basket, toolbox, or bag—you can easily take your art supplies with you on the go.

Anywhere you paint outside of your house, you're going to need a small, portable art-supply container. Since this bag will go with you on your daily activities, you'll have to downsize your art supplies to fit. The first thing you'll need is a small paint palette filled with half pans of your favorite paint colors. Several small palettes are available, but I prefer metal or tin ones with lids that close tightly to avoid leaks.

Add to your bag a sketchbook, pencil, eraser, pen, angle finder, viewfinder, water, tissues, and small water container. A water brush is also great if you don't have any water nearby. Short-handled travel brushes can be preferable to water brushes; they give you more control over the amount of water to mix with your paints. Also, include a clip or two to clamp your palette onto your sketchbook and keep your hands free.

PALETTE PICKS

Choose reliable colors that you will use all the time, and learn what mixtures combine to create new colors. Here are the colors I use most often in my small palette:

- Ultramarine blue
- Burnt sienna (combines with ultramarine blue to make dark brown)
- Permanent rose or permanent magenta (for anything pink or rose-colored)
- Cerulean blue (a soft gray-blue)
- Phthalo blue (an intense dark turquoise blue)
- Lemon yellow
- Lipstick red
- Sap green
- Scarlet lake or red-orange
- Yellow ochre

DIY & RECYCLED ART SUPPLIES

If you don't want to spend money on supplies made for creating art, you can create some of your own out of other household items.

- Make your own palette out of a mint container by placing the plastic grids that fit inside fluorescent lights into the tin to hold the paints. I've recently tried molding polymer clay into mint tins, making holes, and filling them with paint. These work great for mini travel kits too.

- Little jelly jars found in restaurants and hotels make great on-the-go water containers, as do plastic water bottles cut in half. If you need a surface to mix your paints on, use a china plate, and then clean it off afterward.

- If you're feeling particularly crafty, vintage book covers and pages can make for fun and beautiful covers for hand-bound sketchbooks. You can also make a brush and art-supply rollup holder from a cloth napkin, placemat, or piece of felt.

ORGANIZING THE RIGHT SUPPLIES IS CRUCIAL FOR SUCCESSFUL ON-THE-GO PAINTING. IF YOU REALIZE YOU'RE MISSING YOUR BRUSHES OR ERASER ONCE YOU GET TO YOUR LOCATION, THE PROCESS BECOMES DIFFICULT OR IMPOSSIBLE. I FIND IT'S WORTH MY TIME TO PLAN AHEAD, INVEST IN GOOD SUPPLIES, AND BE PREPARED.

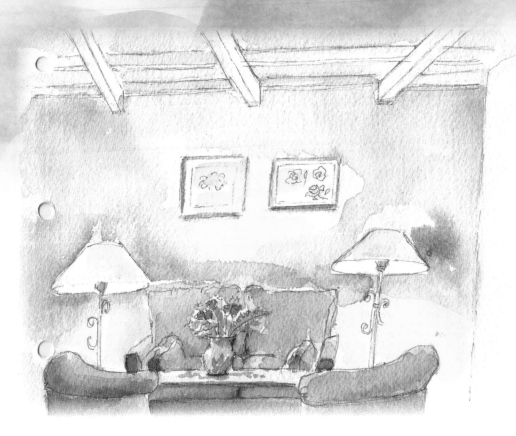

THE PROCESS

You don't need to go out with the intention to draw. Just bring along your art bag as you go about your daily activities, so that it's there when you do find an opportunity to paint or sketch.

Long waits in lines, doctors' offices, or restaurants become perfect art opportunities with the right frame of mind. Just pull out your supplies, and look for something to draw. Then add paint if you still have enough time. Use your regular brushes if you have fast access to a nearby water fountain or sink; otherwise, your water brush will suffice.

When using a water brush, you'll need to clean off the brush to change colors, squeezing a drop of water onto the tip to wipe off on a tissue or napkin. When the wait time is over (and your painting is interrupted), cover the painting with a tissue, close your sketchbook, and take your chances. If you're able to finish entirely, even better—just leave your sketchbook open for the painting to dry. Remember: It's not about making perfect paintings; it's about the process of enjoying what's around you.

CHOOSING YOUR SUBJECTS

If you pay attention to what you find interesting, you'll have plenty of subjects to sketch and paint. If you like mailboxes, try your hand at all of the mailboxes in your neighborhood. Interested in graphics, lettering, and signs? Sketch and paint the signage you see in a journal. Crazy about wine? Paint a still life of the wine bottle on your restaurant table, including the name on the label if you want to remember it. If you like animals, paint your pets, or go to the zoo with your art bag in tow.

I happen to love shoes. I once sketched all of the new colors in a French department store. Every time I open my journal to that painting, I remember how amazed I was at the beautiful colors, and the memories instantly take me back. The point is: Paint whatever you like.

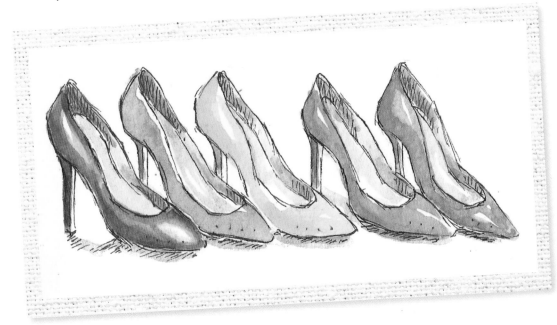

INSPIRATION AT YOUR FINGERTIPS: NOT IN THE MOOD TO SKETCH SOMETHING IN YOUR IMMEDIATE ENVIRONMENT? KEEP SOME PHOTOS OR MAGAZINE PICTURES IN AN ENVELOPE GLUED INTO YOUR SKETCHBOOK. WHEN YOU HAVE SOME DOWNTIME, PULL OUT A PICTURE AND SKETCH FROM IT.

CHALLENGING LOCATIONS

With a little ingenuity, it's possible to paint anywhere, even under the following circumstances.

No place to sit?

If ever I think there may not be somewhere to sit, I bring a small foldup chair when I go out to sketch. The chair fits in my tote bag and isn't heavy. If you have no chair but see a view you want to paint, your tote can also double as a place to sit. For this reason, I prefer old tote bags to nice, new ones.

Odd and dark painting locations?

When you want to make art but the lighting is dim or dark, the solution is simple: Add a small folding light to your bag to set up beside you. I found one that's smaller than a deck of cards and runs on batteries. And I'm so glad I did! I drew one of my favorite sketchbook drawings with watercolor pencils in a dark alcove of a hotel, not worrying about the colors and just having fun. Looking at the drawing even now still brings back all the memories of that moment years ago.

Car painting?

Painting in the car is great ... if you aren't the driver. I use a wooden box with a partition to hold my water cup and as a place to rest my sketchbook. I usually paint from photos in the passenger seat, but I've also parked to paint a view out the car window. This works especially well when it's cold outside or you need somewhere to sit.

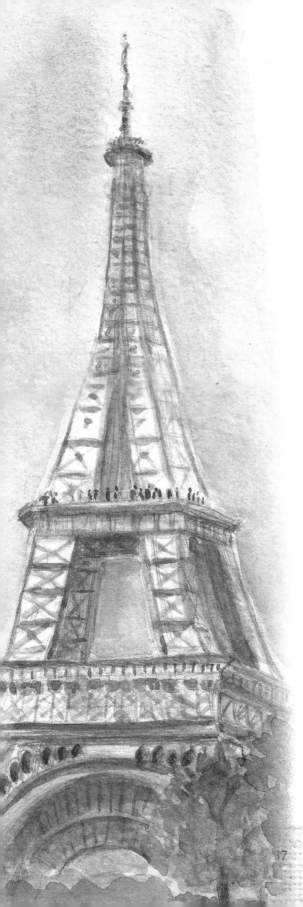

TRAVEL PAINTING

I think the best way to really see and savor a trip is to bring along a small sketchbook and draw what you like. Sitting in front of something and examining its shapes and colors really opens your eyes to appreciate what you're seeing. What better way to enjoy Monet's garden, the Eiffel Tower, or the Washington Monument than by sketching it?

Keep your viewfinder tool (page 17) handy. Like using your camera to capture a portion of what you see, it will help simplify and frame what you want in your painting.

I often paint on trains and airplanes using my photos. I've tried painting little sketches of what I see out train and car windows, but I find I want more time to look at my subject, so I typically am not very happy with the results.

PAINTING FROM YOUR POSTCARDS AND PHOTOS ON THE WAY HOME FROM A TRIP KEEPS YOUR PERSPECTIVE FRESH WHILE THE IMAGES AND COLORS ARE STILL CLEAR IN YOUR MIND.

EXERCISES FOR KEEPING UP WITH YOUR CRAFT

You may not always feel inspired or in the mood, but it's important to hone your skills. If nothing in your surroundings inspires you to draw or paint, look around until you find something you think you might be able to draw. Sketch it, and then draw whatever is behind it, and so forth. Draw as much as you can in your line of vision without shifting your view. This line-of-vision drawing exercise is also great for engaging your senses in the morning as you sit down to breakfast or with a cup of coffee.

Another exercise to learn speed and focused depiction is to create 3-, 5- and 10-minute timed drawings. When your time is limited, you hurry up and draw without thinking too much about it, learning to accept imperfection to get the bigger picture. And that's the key to on-the-go art!

Now that you understand what materials and ideas will enable you to draw and paint anywhere, all that awaits is for you to put your kit together and create as often as you can.

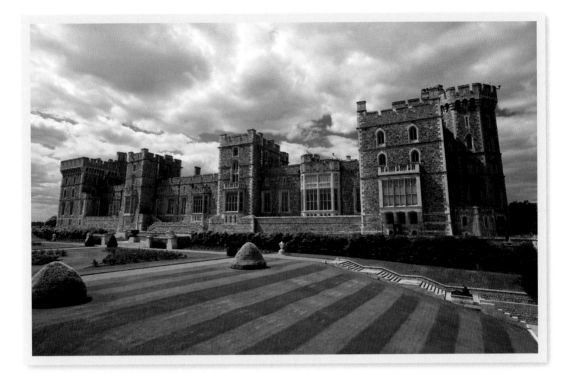

SPECIAL PERMISSION TO SKETCH

In museums or other places, you may find yourself somewhere you need permission to sketch. Although "photography is not permitted" signs are common, you'll rarely see any against drawing. However, I've occasionally been asked to stop drawing by museum guards and docents. Once, a guard at Windsor Castle (one residence of the Queen of England) told me I was only permitted with the express permission of the Windsor family itself. I'm still waiting for the Queen's invite.

Painting From Reference Material

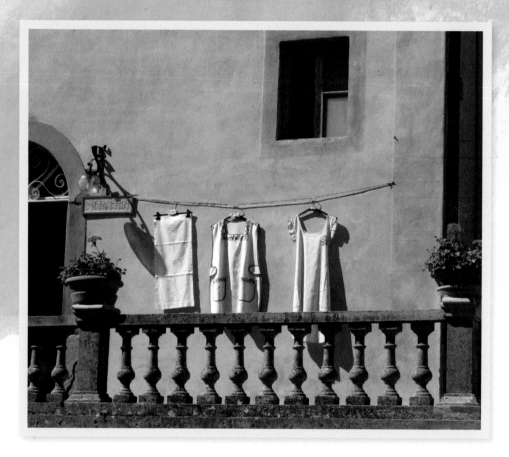

When you're just starting out, painting from reference material is a great way to learn, especially when you don't immediately have inspiration right in front of you. For many of the painting projects throughout this book, I started from an initial piece of reference material. When you think about it, all of the projects in this book are now reference material for you!

When creating a painting using reference material like a photograph, you'll rarely work from something with a perfect arrangement of values from the outset. Don't be afraid to experiment a bit before committing to starting the actual piece.

Try making several small drawings in your sketchbook, experimenting with different compositions and values to determine what you want in the finished painting. Do this by making line sketches with shading (called "value sketches") to test out your composition. Once you've decided on a look you like, use this as your guide for thinking about colors and the overall final design.

Then you have a couple of options for how to proceed, depending on your comfort level and skill:

- Lightly freehand-draw it on your watercolor paper in pencil. A 2H pencil will make a very light hard line that you can paint over.

- Trace it using graphite paper. Start by enlarging your small value sketch on a computer or copier. Sandwich the graphite paper between your watercolor paper and your drawing, and then trace the lines on your drawing through the graphite onto the watercolor paper. If it leaves any graphite smudges, simply erase them with a kneaded eraser.

Once you've penciled your drawing onto the watercolor paper, add any additional details and erase unnecessary lines. The idea is to create a complete sketch that you can build on as you go.

Sometimes, I decide a painting might look better with waterproof ink to create stronger lines. If you decide to use ink, sketch first in pencil, and then draw over it in sketchy ink lines. If you draw your ink lines in one thickness and outline your drawing, the look tends to flatten, so I suggest trying a variety of ink lines or even broken lines as well as different levels of thickness.

The key here is experimentation. If you're not happy with something you've done, consider what you don't like, and start over. There's no wrong way in artistic creation. So use the tools at your disposal, and remember to have fun with it.

LIKE FOLLOWING A ROAD MAP WHEN DRIVING TO A NEW LOCATION, A VALUE SKETCH WILL TELL YOU WHERE TO PUT YOUR DIFFERENT MIXTURES OF PAINT AS YOU GO. MAKING A VALUE SKETCH BEFORE YOU BEGIN YOUR PAINTING WILL HELP YOU AVOID INDECISION ONCE YOU'RE ALREADY HOLDING A BRUSH DRIPPING WITH PAINT.

Desk with a View

Using several reference photos as my guide, I first drew this composition in a sketchbook. It has the feel of a picturesque art nook with a view of a vineyard that any artist would dream of. Then I sketched the scene onto watercolor paper and went over the pencil lines with a waterproof ink pen.

Follow my color guidelines to paint in similar shades, or make your own color choices as you go.

I USUALLY START WITH MY LIGHTEST COLORS, GRADUALLY ADDING DARKER COLORS AND ENDING WITH MY DARKEST DARKS. ADDING A FEW DARK COLORS AT THE BEGINNING, HOWEVER, CAN PROVIDE A NICE RANGE OF VALUES.

STEP 1

Apply blue and yellow onto wet paper, starting with the largest shapes in the sketch, moving to the smallest shapes, and adding details last. Paint the wall with cerulean blue mixed with yellow ochre and a little violet. Fill the sky with a light shading of blue, adding a lavender mixture to the mountain in the distance and throughout the curtains to create the illusion of natural folds.

Burnt sienna and ultramarine blue make a great rustic floor coloring. Add more blue to darker areas. For light and dark shadowing, play with a light, watery application of blue to darken the desk's rear legs where shadows would fall.

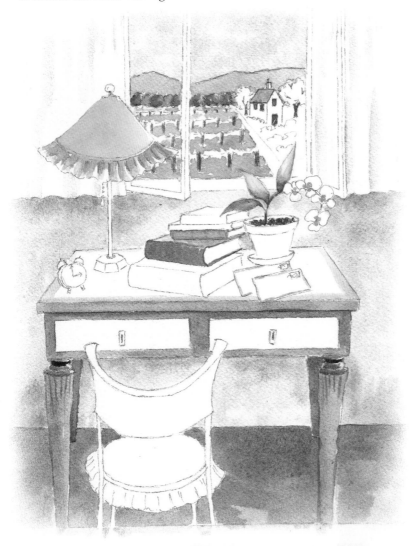

BRINGING IN THE SAME SHADES IN VARIOUS PLACES HELPS MAINTAIN A COHESIVE AND REALISTIC LOOK.

STEP 2

Blue, magenta, yellow, and lavender create lovely foliage outside the window. Once that layer is completely dry, add a watery glaze of ultramarine blue to cast a shadow on the darker side of the house in the distance.

Paint the orchid pot wet-into-wet, adding lighter yellow over the top when dry. Add very little water when filling in the pot and orchid leaves.

WHEN WORKING ON DETAILS, I SUGGEST SETTING THE PAINTING UP ON A SHELF AND LOOKING AT IT FROM AFAR.

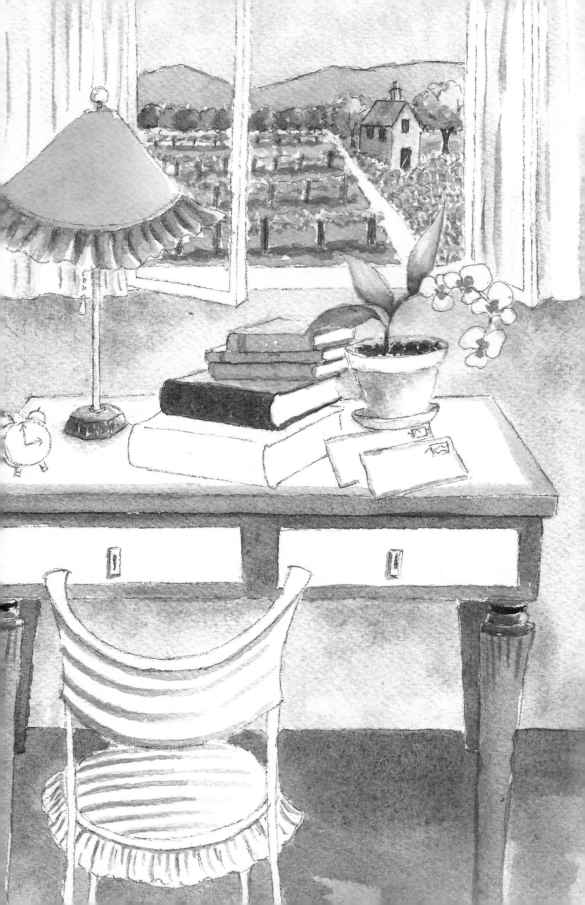

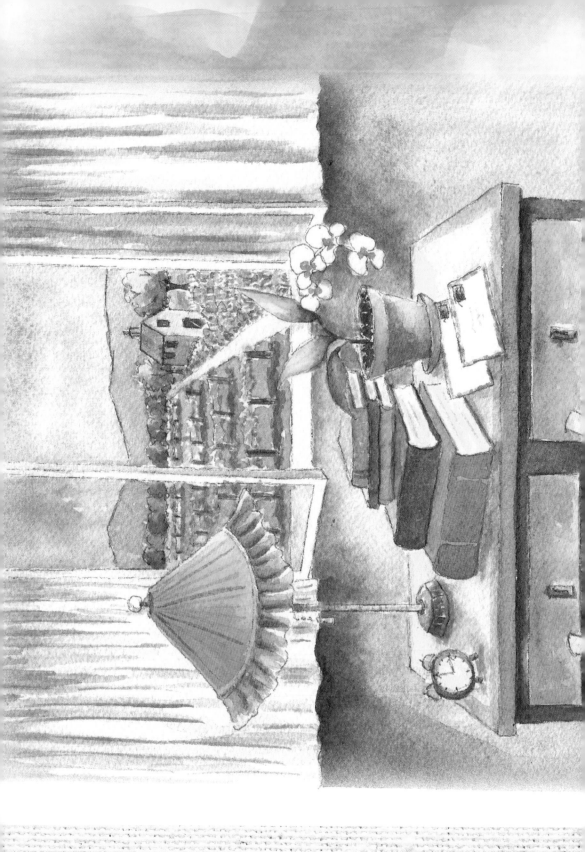

STEP 3

Glaze scarlet lake and lemon yellow over the whole pot. Paint the lampshade wet-into-wet, and paint the books with three values of each paint color. Then fill in the line details on the curtains and chair.

Finalize with small details throughout: Fill in the stamps, pattern the edges of paper, and line the edges of the envelopes. Add more dark blue across the tops of the curtains to close off the top of the painting. Then paint the last bits of detailing throughout—including the clock, desk drawers, and any further shadowing—stopping when the painting feels complete.

CONGRATULATIONS! YOU'VE FINISHED YOUR FIRST WATERCOLOR PAINTING! SHOW YOUR FINISHED PAINTING TO PEOPLE WHO WILL *OOOH* AND *AHHH* OVER IT. CHEERFUL FEEDBACK ON YOUR ARTWORK IS NECESSARY FOR YOU TO GAIN CONFIDENCE.

Laundry Day

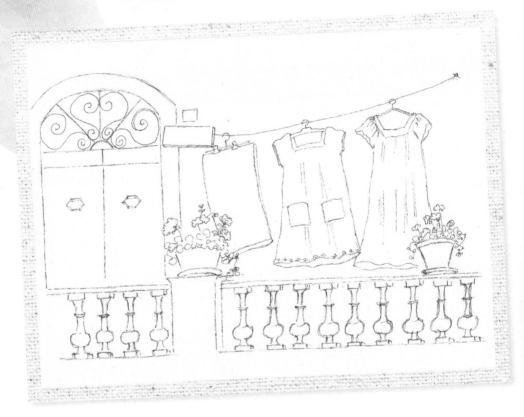

Like something you might see while wandering the street of an idyllic European town, this painting subject holds a timeless charm. Using a photograph for reference (see page 40), I analyzed the composition and determined my ideal framing for the scene. Then I was free to play with color.

STEP 1

Cover the back wall with a mix of blue, magenta, and yellow. To achieve a washed-out look, wet the entire area and float in the paint.

Paint a brown mixture on the front door, and brush two to three layers of gray on the balcony, creating depth by letting each layer dry before applying the next.

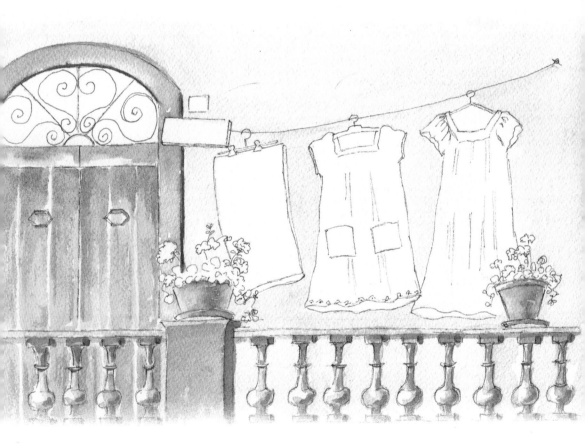

STEP 2

Get creative with the fabrics on the clothesline, choosing colors and patterns that you enjoy. Be sure to add in some shadowed folds as you go. Fill in the terra-cotta pots on the balcony with magenta and yellow, and layer in greens, reds, yellows, and blues for the flowers and leaves.

Then look at the painting from a distance to determine any additional improvements you may want to make. To tone down the colors, carefully add some watery color using very light pressure on the brush.

YOU'LL LIKELY NEED TO EXPERIMENT WITH THE AMOUNT OF EACH
COLOR YOU ADD TO FIND A SHADE YOU LIKE.

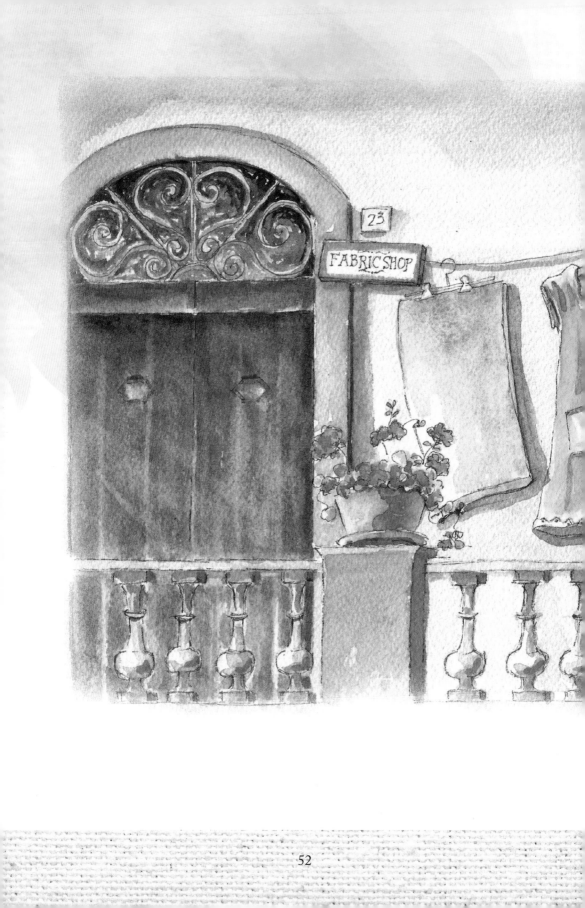

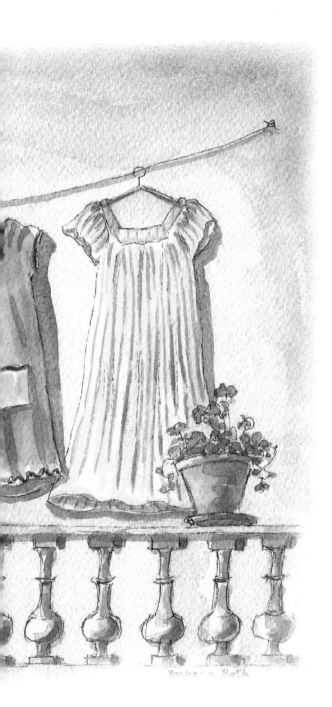

STEP 3

Darken the shadows on the wall with another layer of violet-blue, and fill in the details on the wrought iron above the door. Once dry, add highlights in yellow and orange to create luster and shine.

Finally, add a store name and address number on the hanging signs. I wrote mine in pencil to make sure they fit before going over the lines with a brown waterproof pen.

FOR ADDITIONAL DETAILING IN THE WINDOW, MAKE THE TOP PORTION DARKER, USING MORE WATER TO LIGHTEN THE MIDDLE AND BOTTOM AREAS OF THE WINDOW, AS THOUGH SUNLIGHT IS POURING IN AT AN ANGLE. I PAINTED WET-ON-DRY, WITH CRISSCROSSED BRUSHSTROKES, LEAVING SMALL PORTIONS OF WHITE PAPER SHOWING THROUGH TO RESEMBLE LIGHT DANCING ALONG THE WINDOWPANES.

Giverny Florals

Inspiration for this piece comes from a flower shop near Claude Monet's home and garden in Giverny, France. The vine-covered archway and displays of flowers caught my eye as I rushed to catch a bus back to Paris. Since I didn't have time to stop and paint, I snapped a photo to pick up the project at home.

STEP 1

Draw your subject on watercolor paper, and then trace over the pencil lines with a thin-tipped waterproof pen.

STEP 2

Mix turquoise with yellow to paint the foliage around the archway, adding in more yellow and dark green for sunlight and shadows.

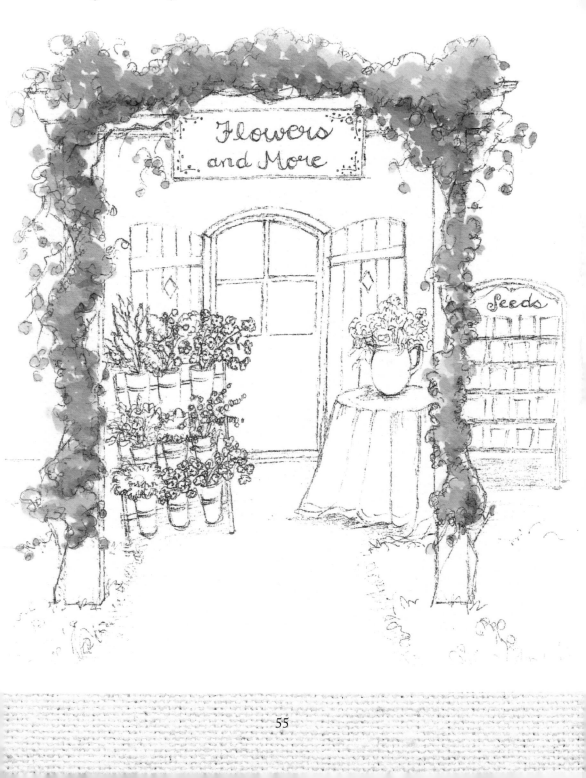

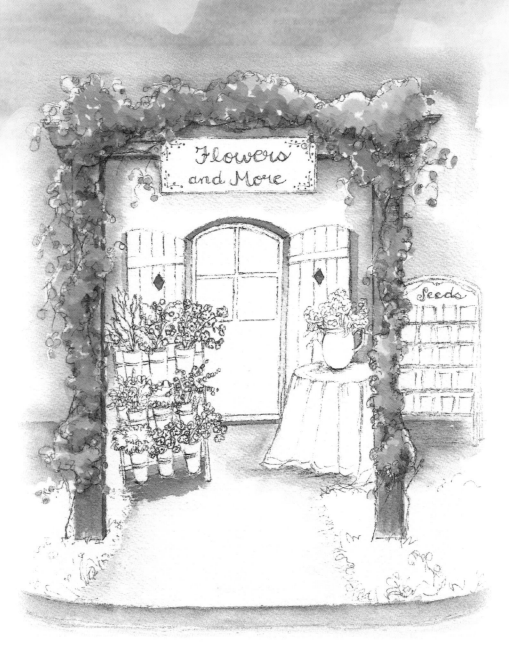

The sign in the image reads:

Flowers
and More

Seeds

STEP 3

Wet the wall area, and paint it with a mixture of phthalo blue, permanent rose, and lemon yellow. This mixture works for the ground too. Paint the archway brown. For the curb in the foreground, mix rose and blue shades, dabbing the paint with a tissue for texture. When dry, glaze a watery wash of yellow across the top.

CREATE PUDDLES OF PAINT WITH SLIGHTLY DIFFERENT PAINT MIXTURES FOR A COLORFUL GRAY WALL.

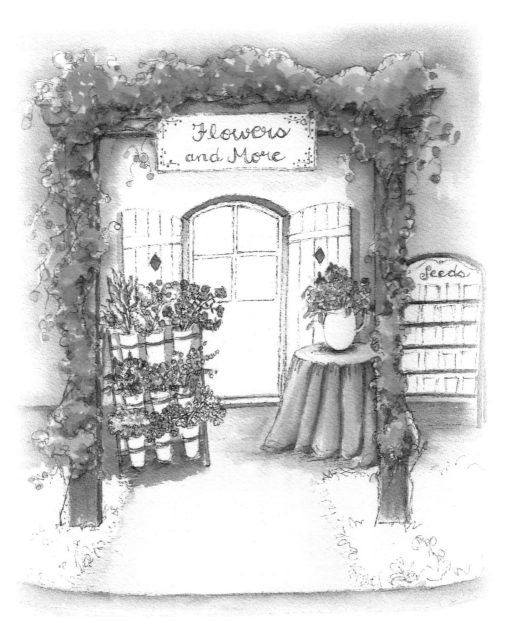

STEP 4

Paint the main areas of the tablecloth a watery blue, using a light mixture on the top and a mixture of about two values darker on the sides. When the tablecloth dries, add some dark creases to it. Paint the flowers various colors.

STEP 5

Use colors already in the painting for the flower arrangements, dulling and brightening areas throughout. When dry, add detailing to the vase. Loosely sketch some vegetables and flowers on the seed packets, filling them in with greens, oranges, and pinks. Use crisscross strokes for the glass panes in the door, leaving slivers of white paper showing to imply light. While the page remains wet, dab in some bright colors for the flowers' reflections. Then paint shadows on the white door with watery blue.

Lastly, mix green, blue, and yellow for the foreground grass, painting the lightest mixture with more yellow in the very front and then gradually adding more greens to recede into the distance.

BEWARE: TOO MUCH WATER WILL CREATE A LARGE WATERY SPOT AND CAN RUIN THE ILLUSION.

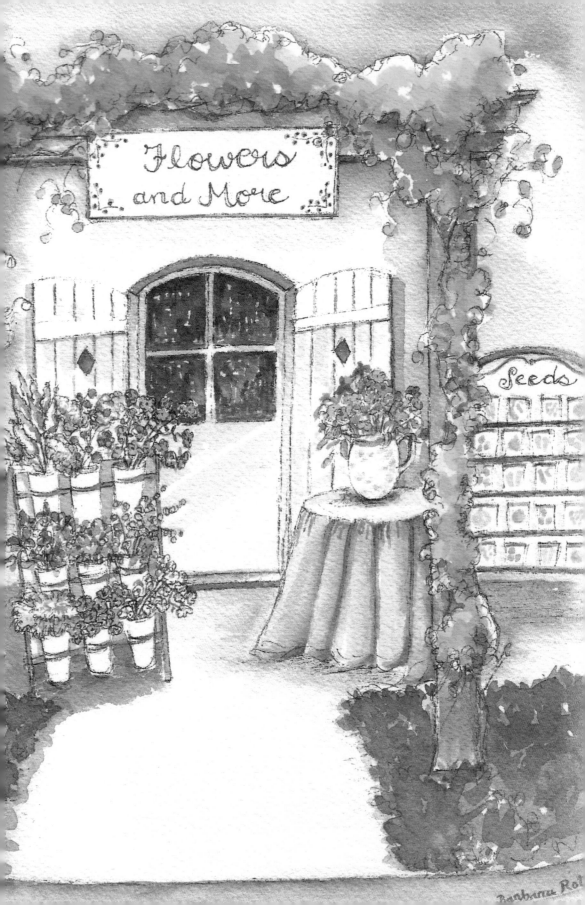

True Italiano

Cobblestones, old stone and brick buildings, laundry-pinned clotheslines, and flower-filled windowsills dot the streets throughout Italy's hillside towns. These are among some of my favorite scenes to stroll through and paint, so I take many photos to draw later for new artwork.

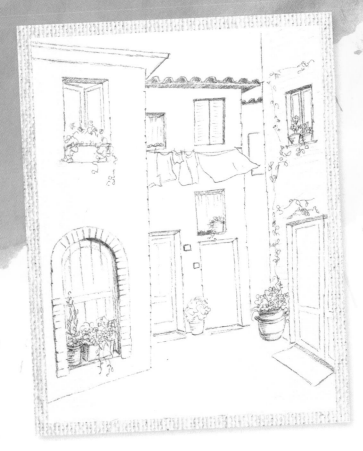

WHEN WORKING FROM PHOTOGRAPHY, BEGIN BY IDENTIFYING THE EYE LEVEL TO ACHIEVE PERSPECTIVE. THE ANGLE FINDER DESCRIBED ON PAGE 17 WILL COME IN HANDY.

STEP 1

For this scene, the roof and bottom lines of the buildings need to be drawn at a slant to create perspective. With a pencil, draw the bottom of the building on the left slanting up toward the bottom third of the page, and then draw the roof line slanting downward. Draw over your pencil lines with waterproof ink.

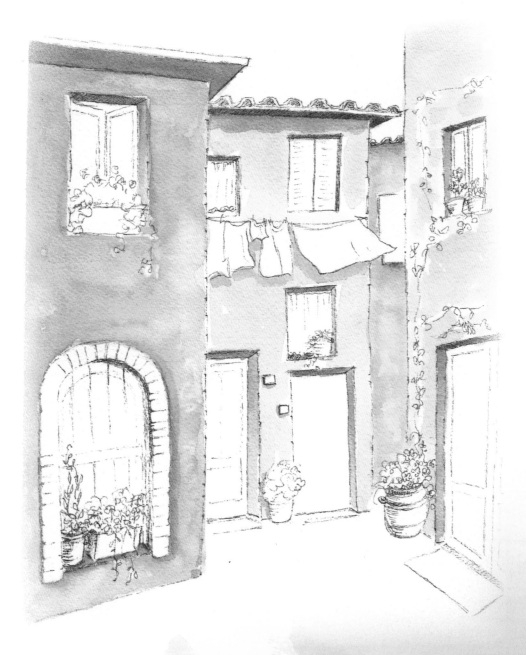

STEP 2

Using the wet-into-wet technique, combine various mixtures of rose, yellow, and violet to paint the buildings. Add shading detail with darker values of each mix for the sides and tops of the recessed windows and doors and for the shadows under the laundry on the clothesline. Use more water for lighter shades on the fronts of the buildings and less for the darker ones in back to add depth.

STEP 3

Fill in the terra-cotta pots, wooden window frames, and doors. Then move on to the shutters and doorframes.

Once dry, add a shadow across the front-left building. Let it dry, and then soften the coloring of the other doors and frames around the windows with a light wash.

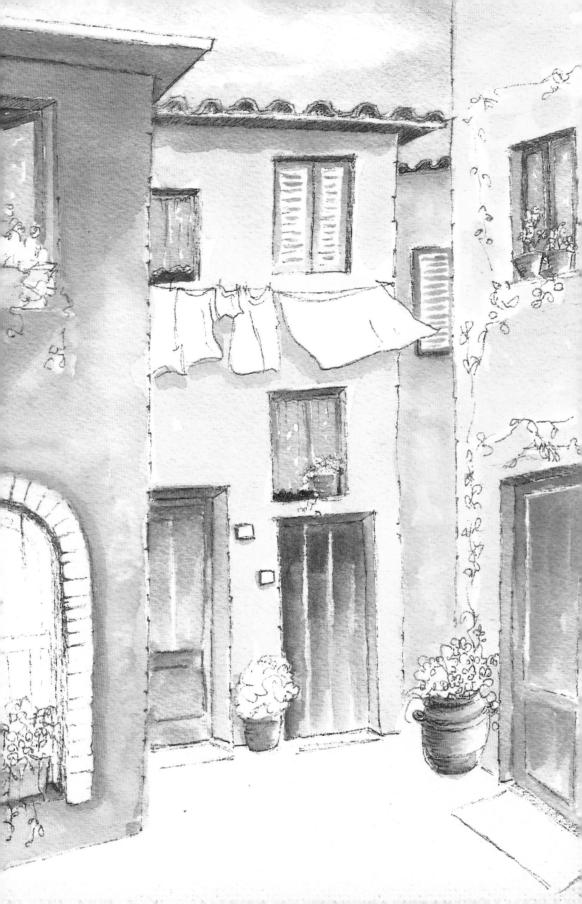

STEP 4

Color the foliage in green, yellow, and blue. Use duller colors to paint the flowers and pots in the middle of the painting to make them appear farther away.

Next, add brick lines around the buildings. Don't paint every brick you see; just paint enough to lead the eye around the painting. Add detail to the brick arch around the blue-green door using differing amounts of orange, yellow, and red. Let the paint dry, and then add brick lines to the building on the right.

For the flowers, pull colors from elsewhere in the artwork: red, orange, rose, blue, lavender, and yellow. Bring the cobblestone street to life with dull bits of these shades, indicating stone lines with darker versions of the mix.

Beachside Dreaming

I never tire of painting the ocean; its colors and conditions are always different. The sea can be a vast source of on-site painting joy, but it can feel overwhelming when determining where to begin.

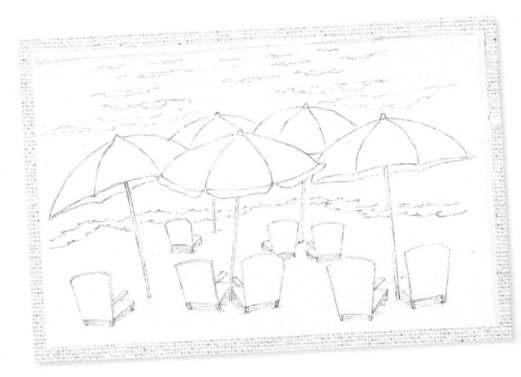

STEP 1

To simplify the subject, analyze the scenery for a good composition. Waves will be smaller and darker along the horizon, with brighter detailing up front. Start by sketching.

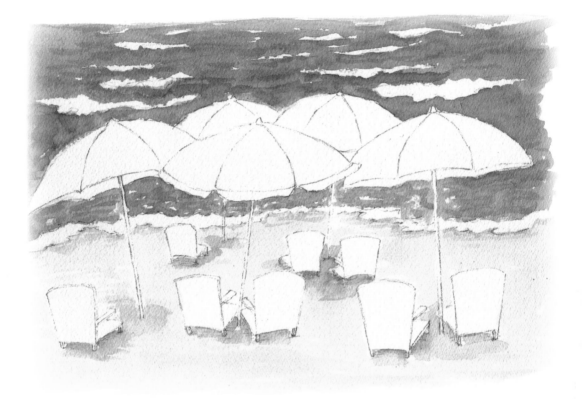

STEP 2

Attach your paper to a board with binder clips. Then begin with a broad wash for the entire ocean area using three puddles of blue and adding some green to one and yellow to the other. Start with the horizon line, and move forward. Begin with the darkest color, brightening as the water meets the beach. Leave white spaces of paper for the waves. Also add sand to the beach and shadows under the foam on the beach, beach chairs, and umbrellas.

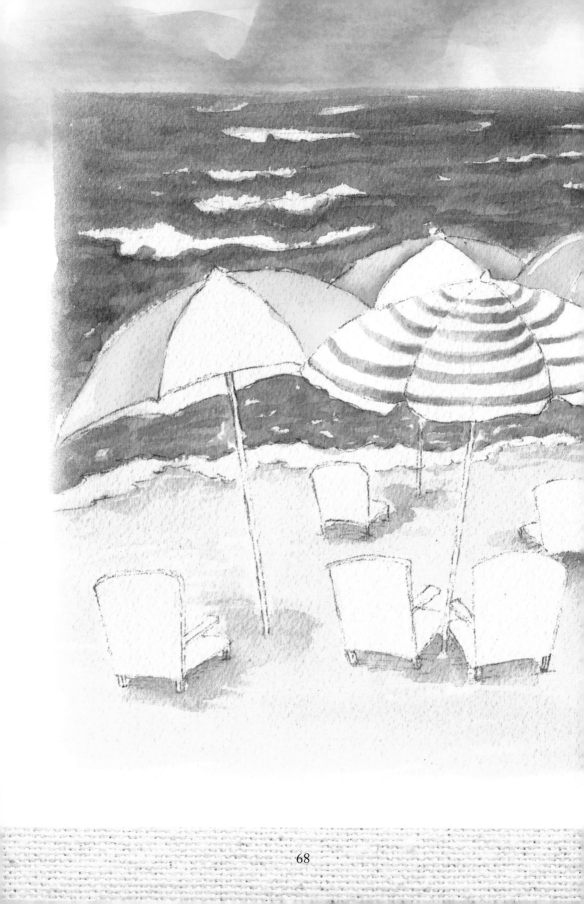

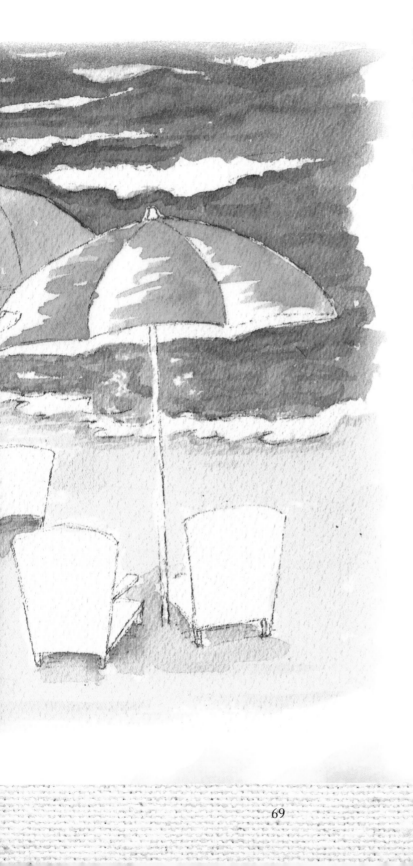

STEP 3

Paint the umbrellas with thin washes of bright colors. Choose colors that complement the colors in the ocean, such as red, red-orange, and pink.

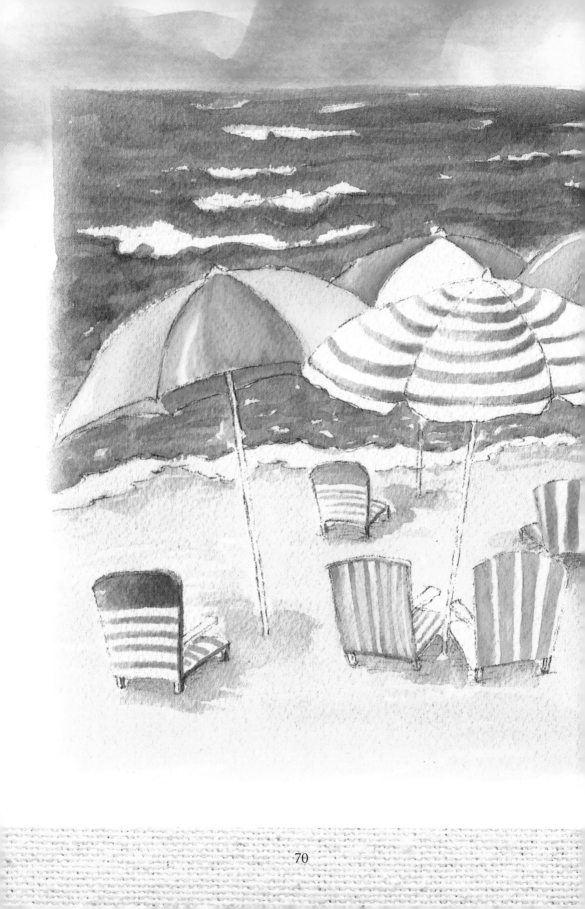

STEP 4

Brush on light washes of color for the beach chairs, and add layers of paint to the umbrellas.

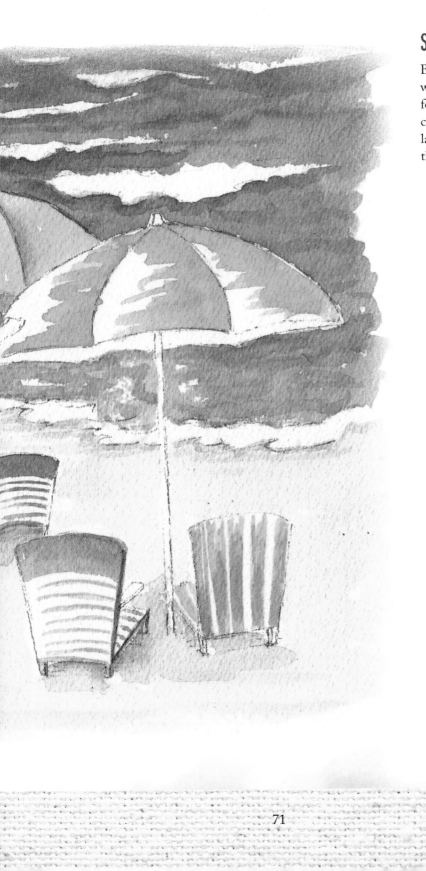

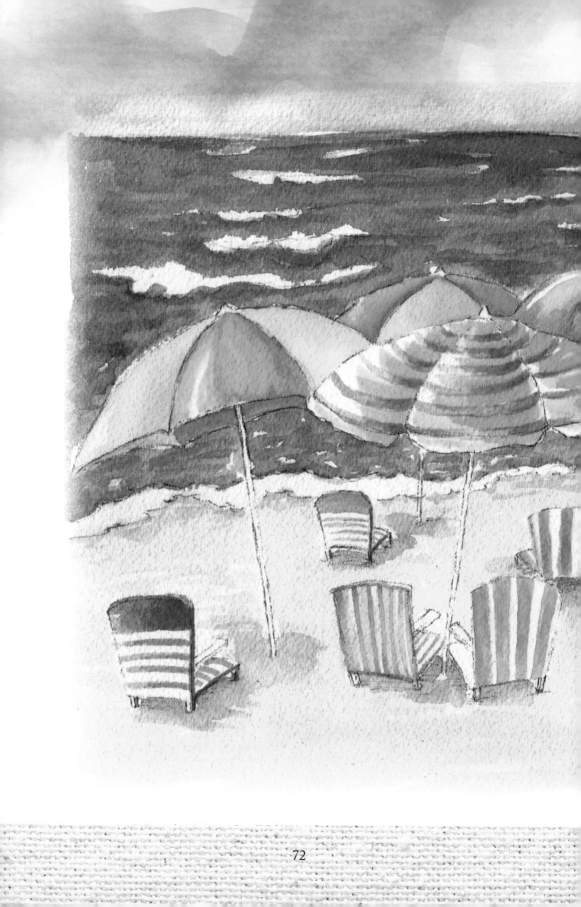

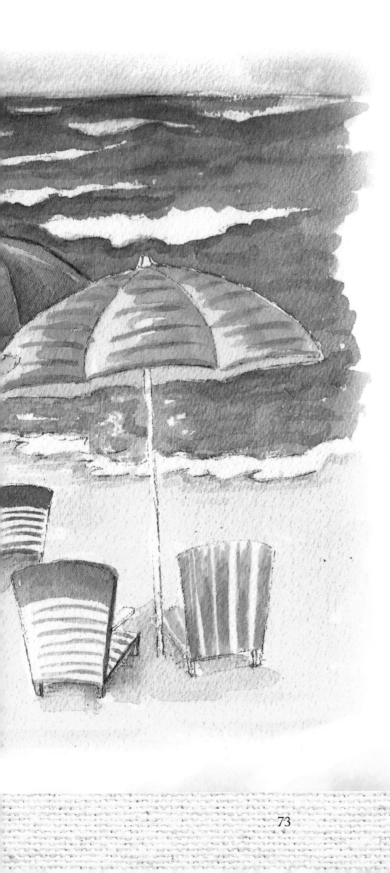

STEP 5

When dry, add more detailed paint layers to brighten the umbrellas, and darken the shadows under the chairs. Paint the sky lavender using magenta and blue, darkening the top to create contrast. While the sky is still very wet, use tissues to dab and lift out some cloud coloring and shapes.

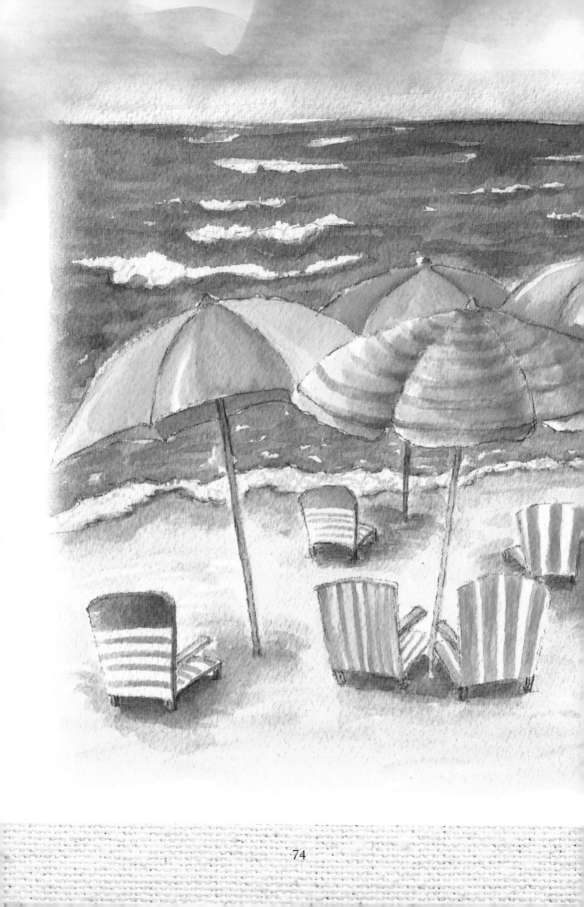

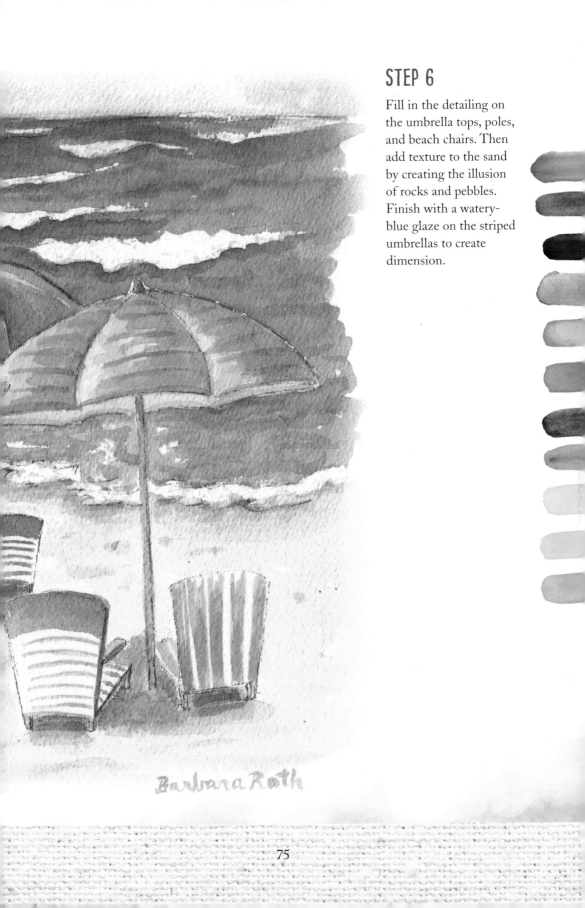

STEP 6

Fill in the detailing on the umbrella tops, poles, and beach chairs. Then add texture to the sand by creating the illusion of rocks and pebbles. Finish with a watery-blue glaze on the striped umbrellas to create dimension.

Barbara Roth

Reader's Paradise

Shop windows are full of interest and intrigue. To capture one well as a watercolor subject, utilize the glazing technique to give an appearance behind glass. If you see a store you like, take a couple of photos up-close and from farther away to view the full details.

STEP 1

Make a quick sketch, including lines for items inside the shop. You will paint over these later.

WHEN I FIRST SAW THIS BOOKSHOP, I WAS DRAWN TO THE COLORS, SO I SOUGHT TO USE THE SAME COLORS IN MY PAINTING. BUT YOU CAN FEEL FREE TO CHOOSE THE COLORS THAT YOU WISH FOR YOUR OWN READER'S PARADISE.

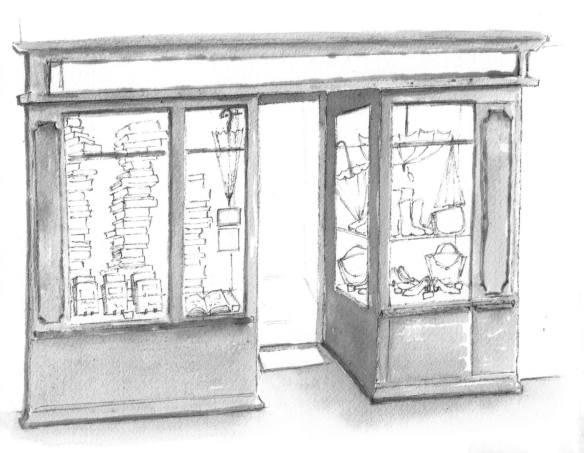

STEP 2

Mix a large puddle of blue on your palette to brush onto the exterior of the bookshop. To add an outline around the wall panels, apply a peelable rubber solution with a ruling pen along the panel outlines before painting on the blue.

Once the rubber solution feels dry to the touch, paint over the lines. Include more layers and darker blue to the inside wall of the door. Add a shadow to the ground in front of the building and to the doorframe using violet and burnt sienna.

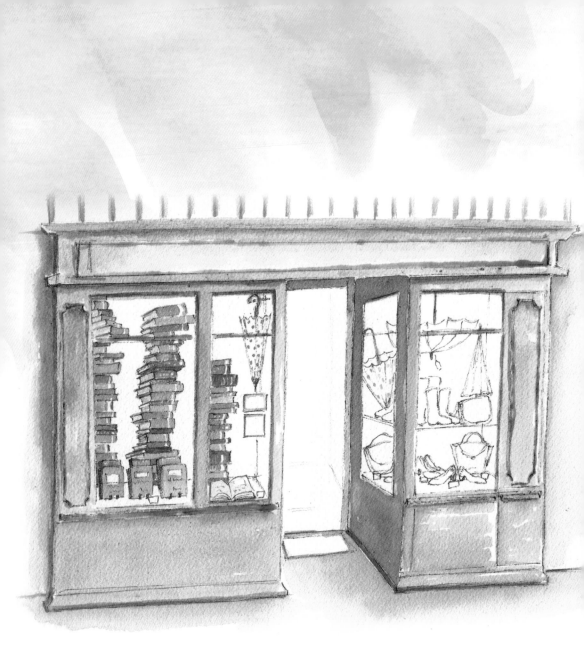

STEP 3

Paint the books in the shop window using a variety of colors
to create overall harmony. To avoid visual chaos, maintain blue
and green values with a few complementary colors thrown in.

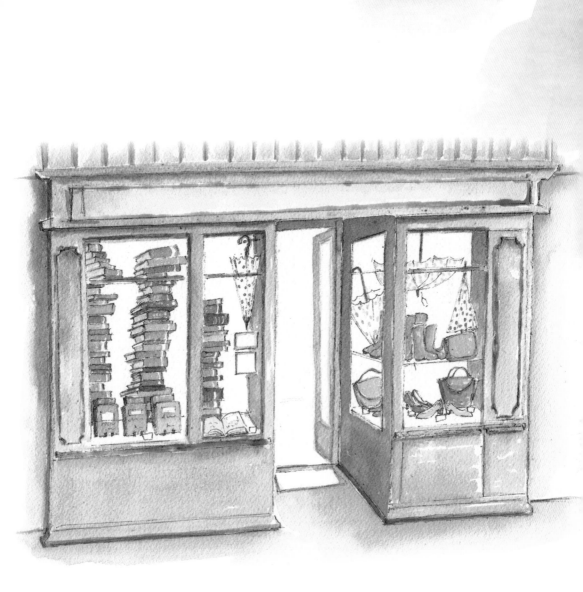

STEP 4

Add a yellow-orange border on the bookshop door, and use the violet-sienna mix for the inside walls by the windows. Then fill in the objects in the window on the right side with complementary colors that don't distract the eye.

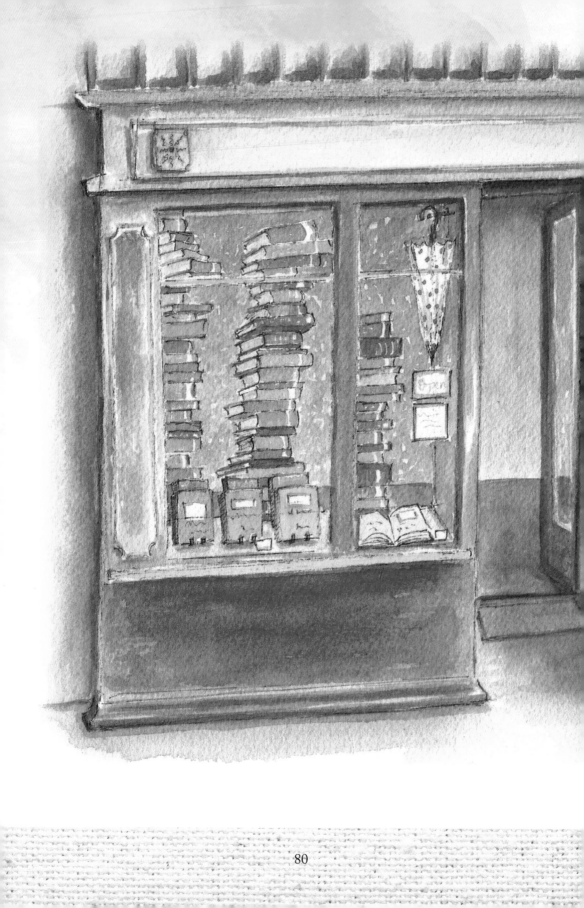

Barbara Roth

STEP 5

Combine different amounts of blue and sienna for the floor and wall inside the shop. Add orange to darken the top of the wall, and rub off the masking solution to reveal a white line around the panel. Add yellow details to the front of the building. Using light pressure, paint watery blue over the window-panes, leaving some slivers unpainted to simulate light reflecting on the windows. Soften the edge of the inside door, and darken the door itself so that it looks like it opens inward. Then add a few more shadow details to the top and sides of the building.

Ciao, Vespa

Some things just beg to be memorialized as art. The moment I saw a pink Vespa scooter on a trip to Tuscany, I just knew it needed to be the subject of a painting, so I snapped a photo to paint later. Using the photograph as reference, I changed all of the colors to fit with the pink Vespa and added some flowers to complement and round out the composition.

STEP 1

Draw a quick pencil sketch to determine the shadows and values you want in your painting.

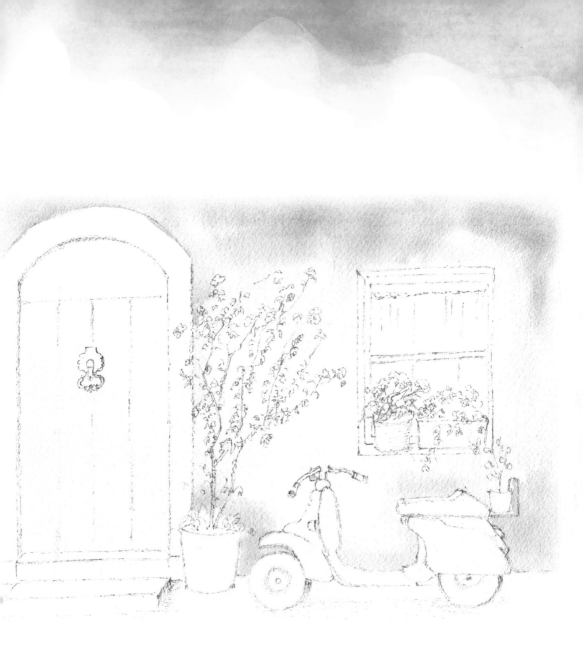

STEP 2

Paint the background wet-into-wet with a mix of blue and violet. Add a few darkening layers at the top and around the scooter.

STEP 3

For the cement arch around the door, brush on a mixture of buff titanium, burnt sienna, and a tiny bit of violet. Add texture with extra dabs of color throughout the arch. To lighten any areas, just add more water.

 Then paint the left side of the window and a few shadows around the large pot and back of the scooter.

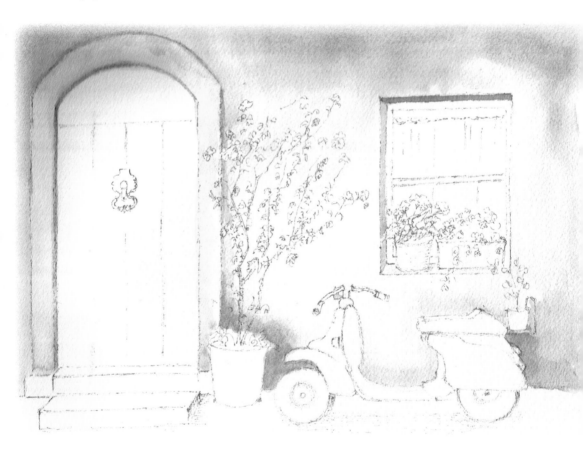

STEP 4

Make the scooter pop using brilliant pink. Water it down for the lightest area of the scooter, and mix it with magenta for any medium-value areas. To create a nearly black color for the tires, mix ultramarine blue with burnt sienna. Darken the shadows under the scooter, on the sides of the door, and around the inside of the window.

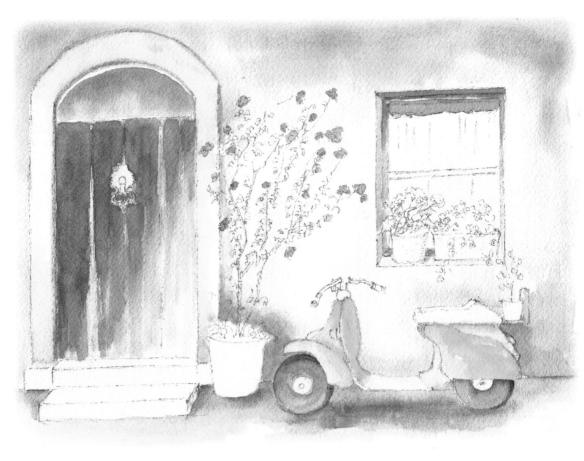

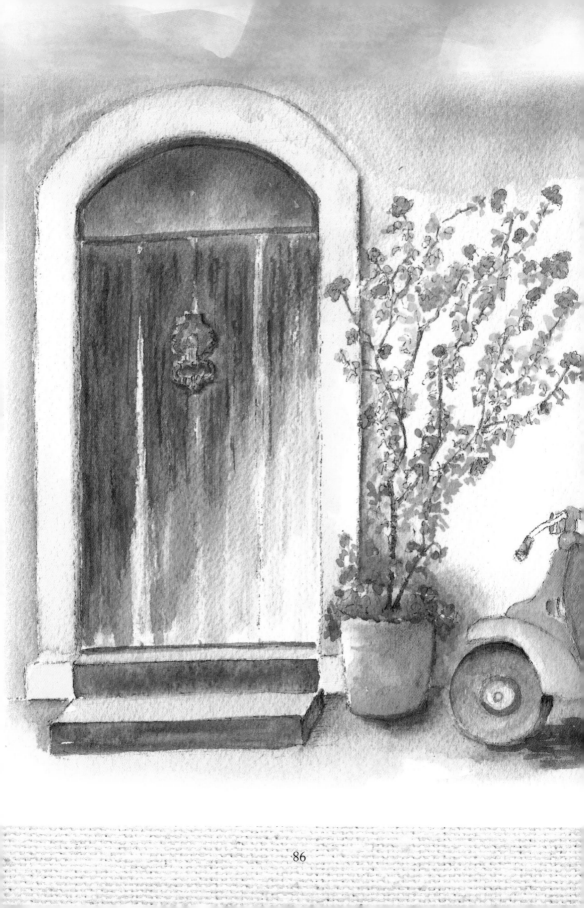

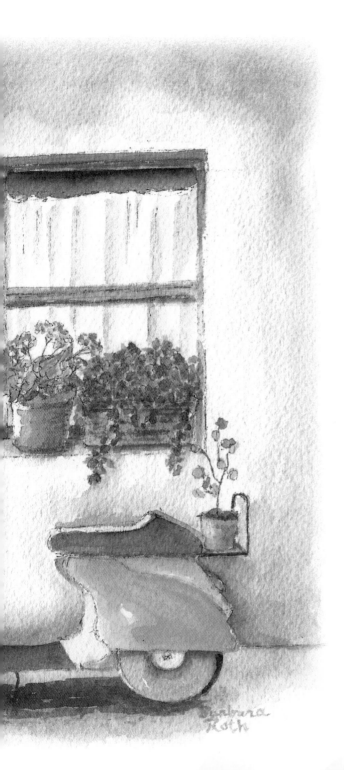

STEP 5

Use a mix of yellow and violet for the ground and foreground, adding more violet for the shadowed area on the ground. Paint all of the plants using magenta, violet, blue, and green, adding yellow to create dimension.

Using a liner/rigger brush, paint thin lines of burnt sienna and blue for the branches of the climbing rose. With a dry brush, add this color to the door to create texture and shading.

With a magic-eraser scrubbing sponge, lift out most of the colors from the flower bed if they look too intense. When dry, dab in some flowers and more blue-green on the leaves.

CREATING SYMMETRICAL TIRES CAN BE CHALLENGING. DON'T WORRY ABOUT THIS, THOUGH, YOU CAN EVEN OUT THE SHAPE AND SIZE BY ADDING MORE PAINT.

STEP 6

View the painting from a distance to determine where it could use more work. Look for opportunities to move the viewer's eye around the painting, such as by adding pink to the left side of the scene. Brush clean water on the window area, and drop in a little of the hot pink on the window above the door.

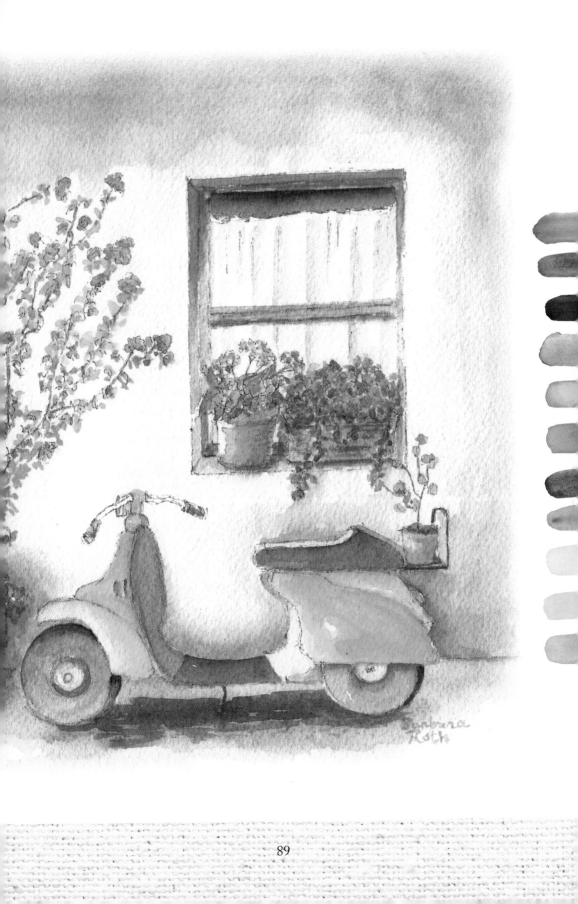

The Meadow Lamb

This project offers lessons in a variety of techniques. It's a great way to learn how to paint a landscape. Create a feeling of depth and atmospheric perspective by painting the background in a dull color, the middle ground in a medium shade, and bright colors for the foreground and details.

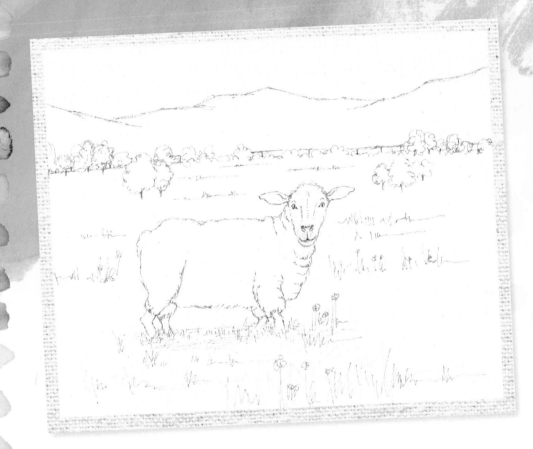

STEP 1

Start with a line drawing.

STEP 2

Paint the blue sky wet-into-wet, and then dab out cloud shapes using a tissue. Soften the clouds' edges by rubbing them with a moist, clean brush, and darken their bottoms to gray.

Next, move on to the sheep's facial features, filling in the nose, lips, and ears with pink.

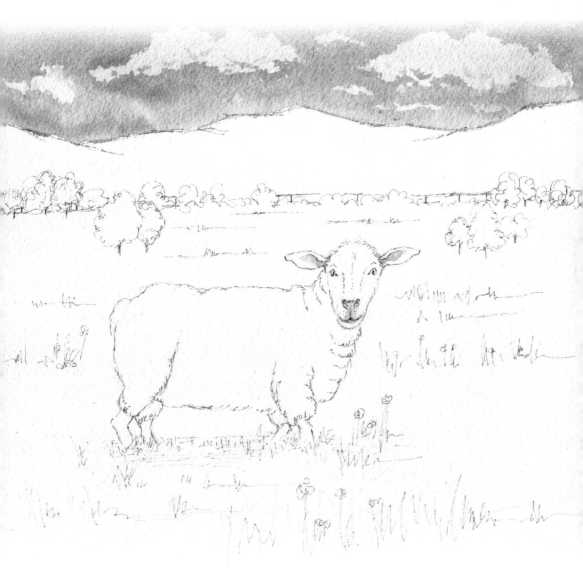

STEP 3

Place rubber masking solution where you will later add color to the flowers. Add the background in the distance by painting the mountains with a mixture of blue and burnt sienna. Add grassy areas with yellow-green, starting with the foreground and moving back.

Paint smaller and smaller patches of darker shades of green as you move to the middle and background. Once dry, add bits of yellow.

STEP 4

Unify the grassy area with a wash that moves from under the trees and into the foreground. Dip a liner brush into various shades of green, whisking the brushstrokes to create blades of grass in the front and middle of the painting. Achieve depth by making the brushstrokes larger in the front and smaller as they fade into the middle ground.

Then create some various color mixtures for the trees to keep them from looking too uniform, painting in alternating shades with yellow mixed in.

PRESERVE THE WHITE OF THE PAPER BY USING A MASKING FLUID PEN ON THE FLOWERS.

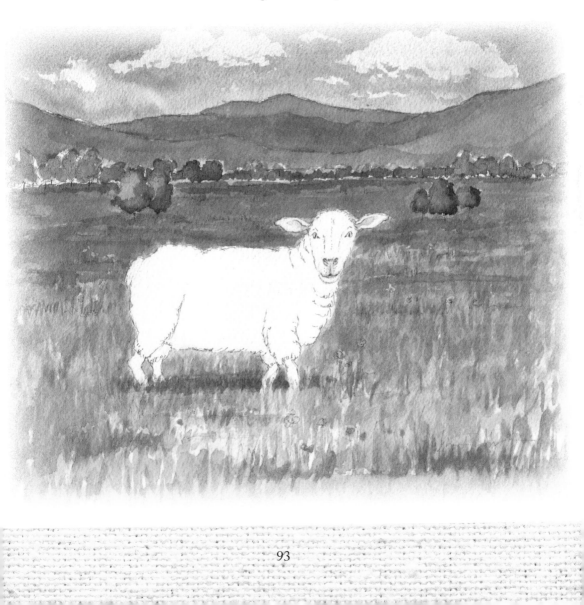

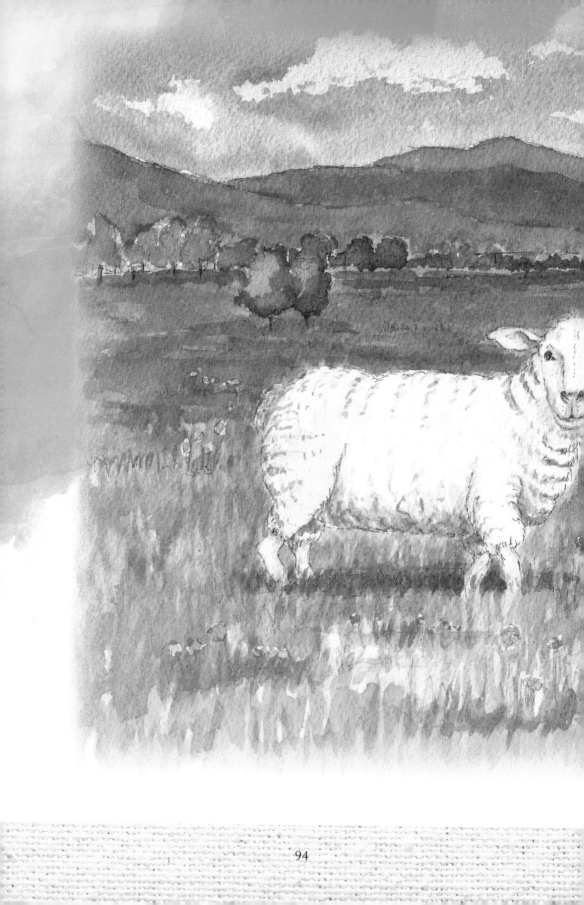

Barbara Roth

STEP 5

Moving back to the sheep's features, paint the eyes yellow with a touch of burnt sienna. Then create curved lines around the sheep's body to give it better definition. Create shading and fur marks, and add a little watery blue for variety in the coloring. Once dry, rub off the masking fluid from the flowers, and paint them in bright yellow-orange, magenta, and pink. Use the liner brush to stroke in a thick mix of yellow-green to look like grass around the flowers.

THE LAMB IN THE PROJECT WILL HELP YOU LEARN HOW TO INCORPORATE WHITE INTO A WATERCOLOR PAINTING. TRADITIONALLY, WHITE PAINT ISN'T USED IN WATERCOLOR. INSTEAD, YOU SHOULD USE THE PAPER'S BLANK AREA AS YOUR WHITE PORTION, AND PAINT OTHER SHADOWS AROUND IT.

La Tour Eiffel

Sketching a famous land-mark, especially one you have dreamt of seeing and painting your whole life, can feel overwhelming. But you can create a lovely drawing and painting if you use the tools you've learned thus far. This painting is based on a sketch I did from a bench in front of the Eiffel Tower.

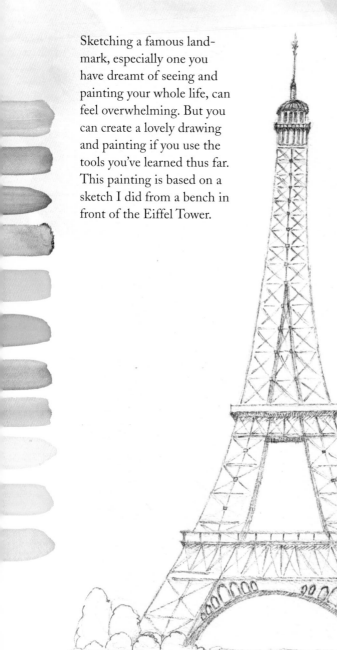

STEP 1

Crop a view with your viewfinder before sketching out the main details. Add ink on top of your pencil lines to better depict all of the patterns in the structure.

IF YOU FIND YOURSELF ABLE TO SIT AND RECREATE ONE OF YOUR FAVORITE PLACES, REMEMBER THAT YOUR SKETCH DOESN'T HAVE TO BE PERFECT. AFTER ALL, YOU'RE CREATING A MEMORY, NOT A MASTERPIECE.

STEP 2

Since this subject has a large area of sky behind it, making the sky more dramatic can help to create interest. Using the wet-into-wet technique, cover the sky with clean water, and then create puddles of paint on your palette for each color in the sky before applying them to the page. Start with magenta, blue, and rose, fading from orange and ending with yellow along the bottom of the tower.

Quickly dab out some cloud shapes with a tissue, adding a little pink to the shapes to create dimension. Dab away any blossoms of color so that the pink shading looks faint and natural.

WHEN COVERING A LARGE AREA OF PAPER WITH WATER, MAKE SURE THE PAPER IS WELL SECURED TO YOUR BOARD.

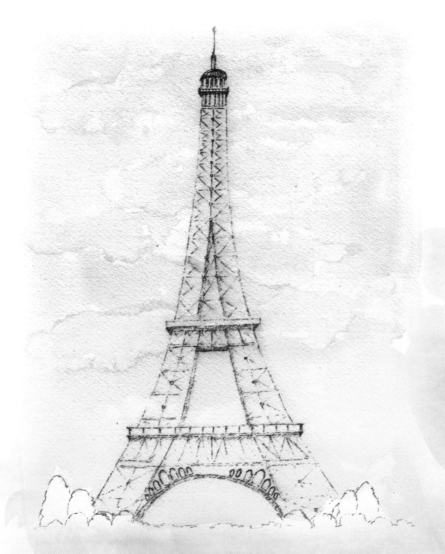

97

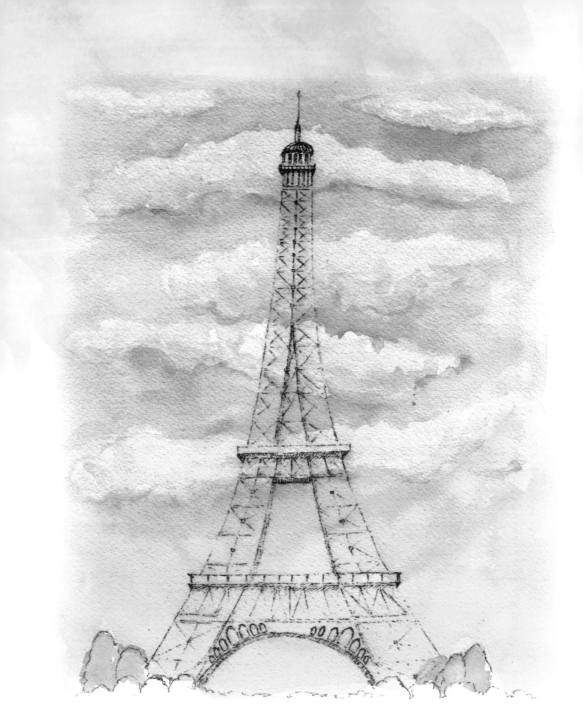

STEP 3

Add more of the same colors to the sky to brighten some areas
before turning to the trees with a watery mixture of blue and yellow.
Darken portions of the clouds with dull gray, softening their edges.

STEP 4

For the tower itself, select differentiating amounts of burnt sienna and magenta with orange for the highlights. Use blue for the glassed-in areas on the tower, along the sides of the structure itself, and the shadowed, receding parts of the structure.

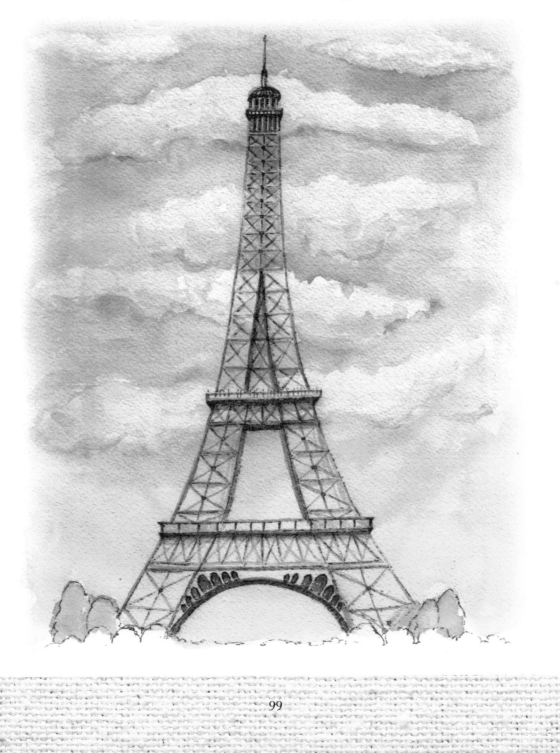

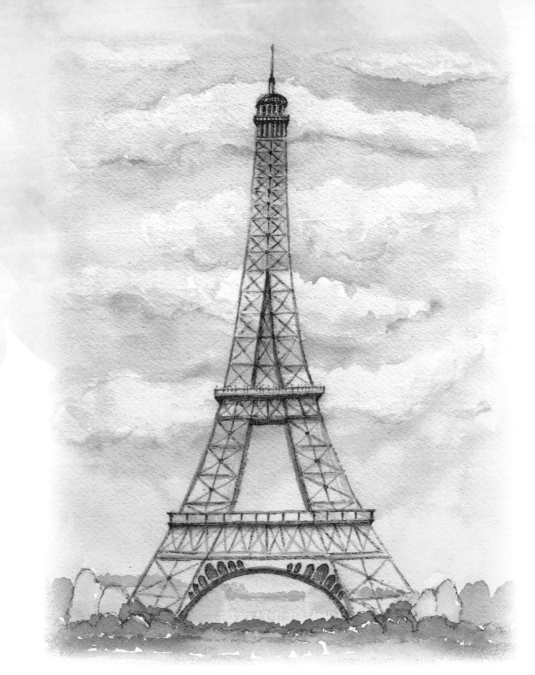

STEP 5

Create depth in the trees and shrubbery by making the colors under the tower's shadow darkest and by brightening the foliage in front. Bring the foreground forward by painting a line of yellow across the front and a line of magenta across the bottom to close it off.

To paint the faint buildings in the background, use watery washes of yellow and pale magenta. Add some watery blue lines behind the tower.

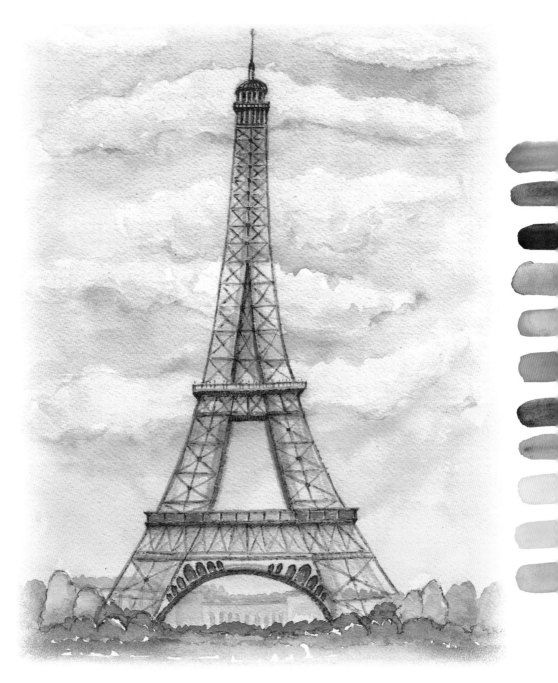

STEP 6

If the yellow-orange paint in the very front of the painting looks out of place, blend it with an eraser sponge. Once that area dries, repaint it with a light-green and yellow wash so that it looks like grass. *Et voilà!*

Monet's Garden, Revisited

Picking just one view to paint in Claude Monet's garden at Giverny is difficult—everything is paintable. After all, one of his reasons for creating the garden was to paint it. It's a humbling experience to think that you might be standing where Monet painted.

STEP 1

Lay out your painting using a detailed drawing.

STEP 2

Start with the tulip patch, filling in the greenery.

STEP 3

Paint the foreground a mixture of yellow and green, making it mostly green in the middle. Darken the back by adding blue.

Dab in lighter blue for the little flowers in the foreground, making them smaller as you move backward. Add green for the tulips' stems. Then mix in some brighter blue for the darker areas in the flower patch. Paint a wash of blue and green to cover a lot of the white crevices in the foliage. Add dimension to the patches of blue flowers with violet.

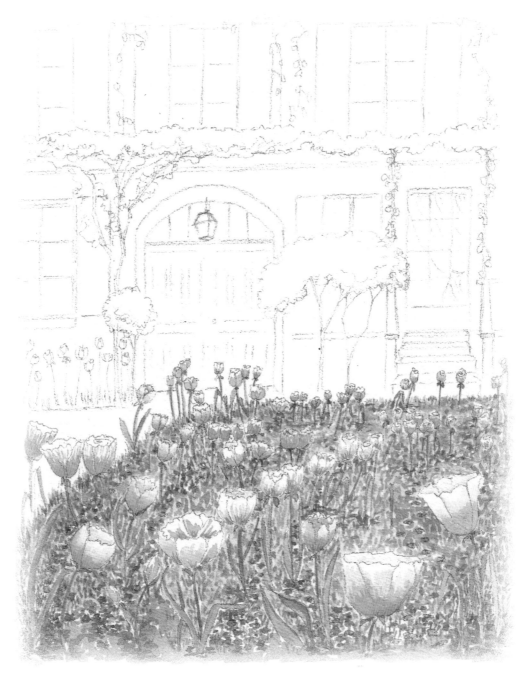

STEP 4

Fill in the tulips with red, magenta, and a little bit of yellow. Paint them all with a light color first and then repeat, adding less water to the paint to create more depth.

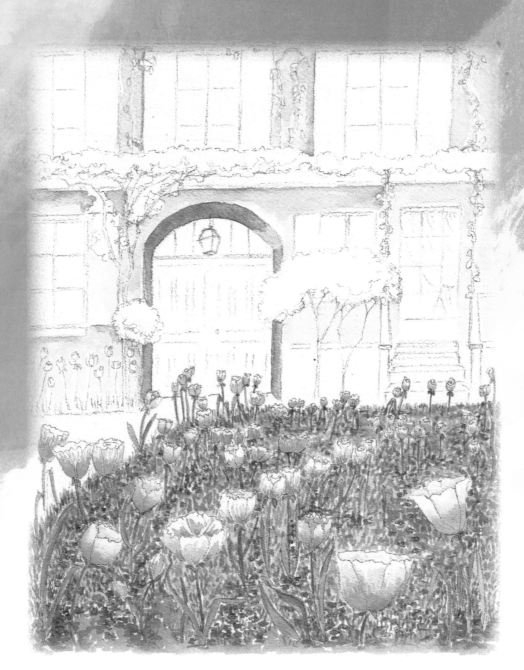

STEP 5

Move on to the house, painting it watery blue and magenta. When the pink is dry, add orange in various areas to suggest light hitting the house's surface. For the shadows around the arched door, add yellow to create a blue-gray. Color the top of the inside of the arch with a darker mixture, and lighten the sides.

STEP 6

Shade the darker areas in the door. Paint the windowpanes with watery blue, and while very wet, add just a touch of each flower's color to create reflections in the top windows.

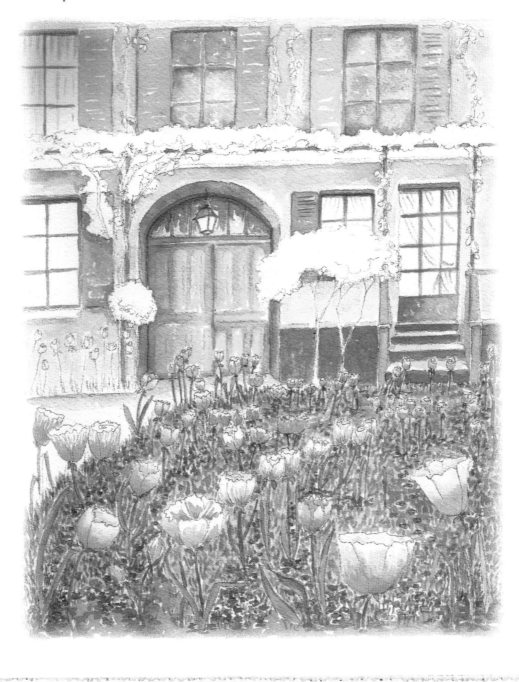

STEP 7

Add darker layers of paint to the flowers in the front to make them stand out, adding bits of lavender in little bunches to lead the viewer's eye through the painting.

For the trees, mix darker yellow with green. Then fill in the green vines climbing the house. Color in the tulips on the left side of the house. To make them appear to recede, use duller shades than the tulips in the front.

Look at the painting from a distance before adding your final touches. Brighten the building with three different puddles of pink, and then glaze these individual mixtures over any areas that need brightening. Do the same with blue paint for any additional shadows.

KNOW WHEN TO FINISH. ALTHOUGH YOU MAY SEE ADDITIONAL OPPORTUNITIES TO ADD DETAILS TO A PAINTING, RESTRAIN YOURSELF BEFORE YOU CLUTTER THE SCENERY.

Archway Luncheon

Sometimes you just want to have fun with your subjects. For this painting,
I combined many of my favorite things: cupcakes, lemonade, vintage china,
turquoise chairs, and Cypress trees. My visual references here were old photos,
my china collection, and chairs that I painted at home.

STEP 1

Begin with a simple drawing,
including all of the elements
you see here.

STEP 2

Paint the tablecloth wet-into-wet
using pink with a drop of rose. Also
fill in the flowers, adding turquoise
mixed with yellow for the leaves.
Then color in the pears, using
the same shade for the pitcher of
lemonade. Combine yellow and green
for the grass before moving on to the
turquoise chairs.

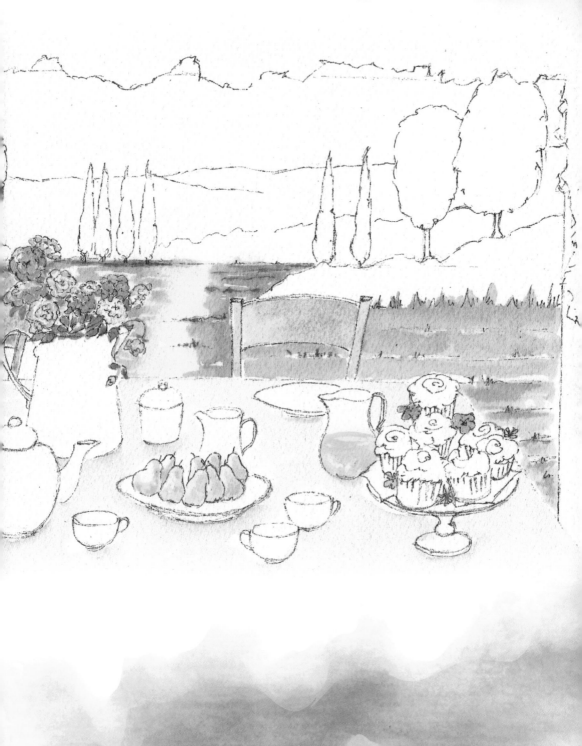

STEP 3

Use the same shade for the wooden patio structure and mountains in the distance as well as the tree trunks. Next, fill in the sky, painting it wet-into-wet before dabbing out some clouds. Add details to the china, and fill in the other glass pitcher.

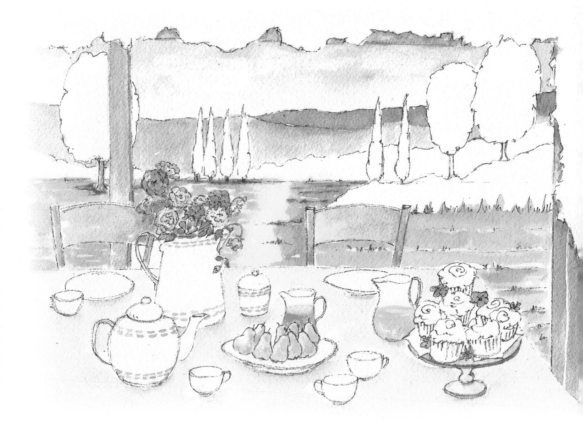

STEP 4

In front of the mountains, paint the greenery and larger trees with green and burnt sienna.

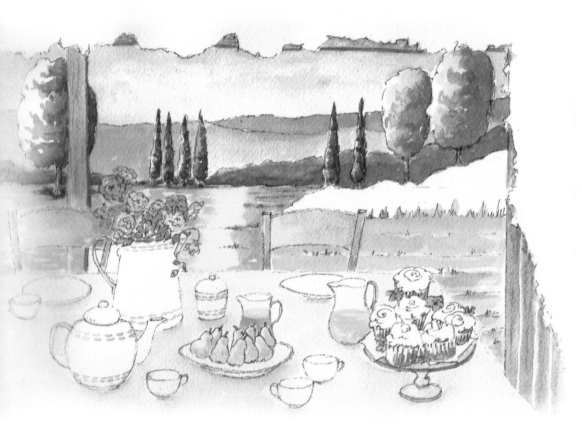

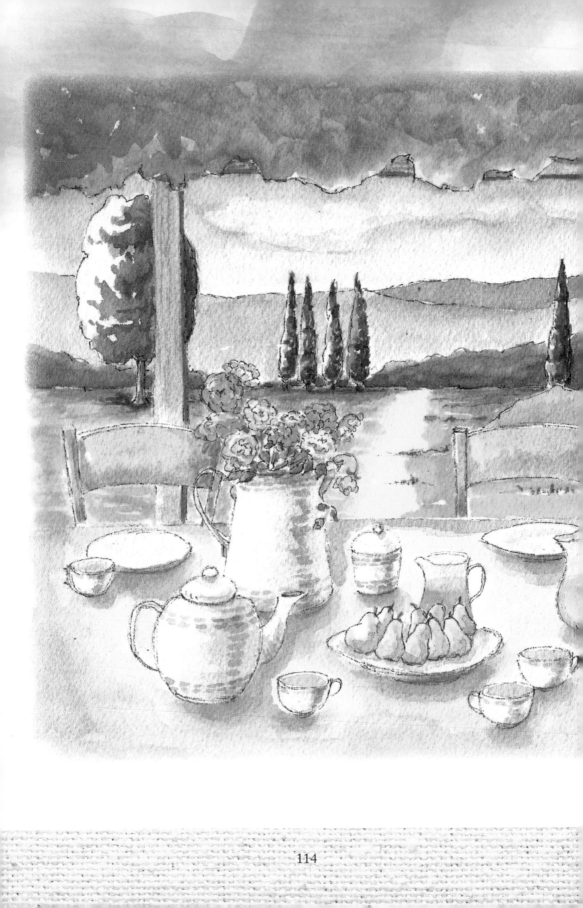

STEP 5

Finish the rest of the foliage, painting the vines above the table with yellow in the brighter areas and a bit of blue for shading. End with the shrubs closest to the table. Fill in the details on the table. Paint the shadows with violet and pink. Ice the cupcakes in pink and orange, and then shade the pears with watery violet. Paint watery blue over the existing color in the pitchers so that they appear to be made of glass. Then add the same color for the shadows on the dishes and in the cups.

SHADING AND PERSPECTIVE: TO CREATE ATMOSPHERIC PERSPECTIVE, FADE OBJECTS INTO THE BACKGROUND USING COOLER, DULLER COLORS. ALTERNATIVELY, USE WARM, BRIGHT COLORS TO MAKE THE FOREGROUND STAND OUT. VIOLET IS THE DARKEST COLOR ON THE COLOR WHEEL AND CAN BE USED TO DARKEN ANY COLOR. TO DULL A COLOR, ADD ITS COMPLEMENT.

STEP 6

Darken the shadows under the trees in the background with layers of green and bright blue. Paint darker foliage above the table, lifting out a few light areas with a sponge or paper towel. Then darken the sky underneath the edge of the overhead foliage for contrast. Bring in a line of lavender paint above the mountains to tie it in with the tablecloth.

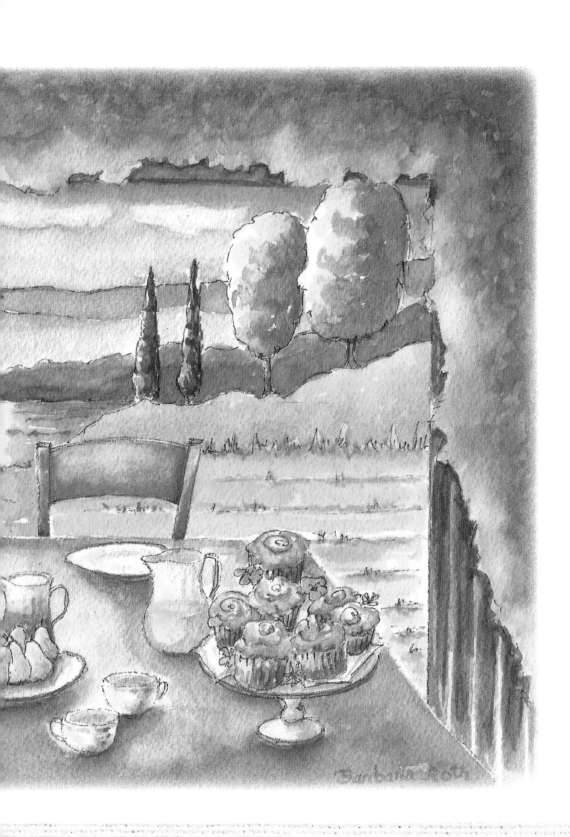

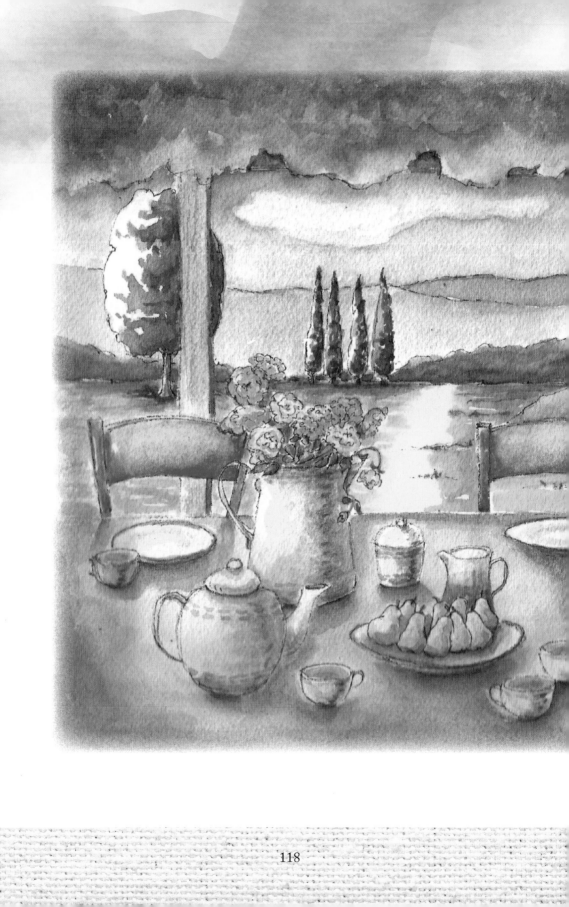

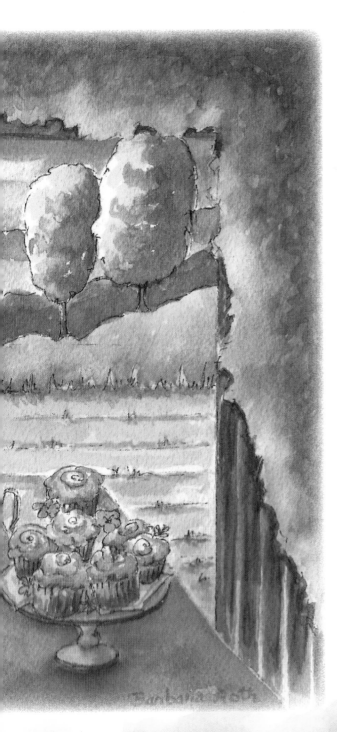

STEP 7

Add more layers of turquoise to the chairs, and look for areas to pull the color in elsewhere on the table. This will prevent putting too much focus on the brightness of the cupcakes and instead move the viewer's eyes around the scene. Now play with lights and darks. Then shadow the cupcakes, and darken the tablecloth's shading. To create light hitting the table, add yellow glazes to most of the objects.

IF YOU FIND THAT THE SHADING LINES ON THE CHINA, ESPECIALLY THE TEAPOT, LOOK MORE LIKE CRACKS, LIFT OFF SOME OF THE LINES BY GENTLY BRUSHING THEM WITH A BRUSH DIPPED IN CLEAN WATER. THEN DAB OFF SOME OF THE COLOR WITH A TISSUE. USE A WATERY MIXTURE OF BLUE AND MAGENTA TO PAINT THE SHADED SIDE OF THE CHINA ON THE TABLE.

Mountainside Sunset

With different colors in the sky every day, sunsets offer a wonderful painting subject, especially when using watercolors. Someday, I want to keep a sketchbook recording daily paintings of the sunsets I see. In the meantime, though, I paint from the photos I take whenever I capture a beautiful sunset. That's how this painting came to be.

STEP 1

The initial sketch can be fairly loose.

STEP 2

Starting with the sun, paint its round shape, and add yellow surrounding it and into the foreground. The sun should appear to radiate a path of light. Then add yellow lines coming from the sun, mixing in some orange.

Turn the painting upside down for a fresh perspective on the rest of the sky. Mix some magenta into the orange, gradually leading to pure blue across the top of the picture. While the sky is wet, lift out some clouds with a tissue.

STEP 3

Turn the painting back around, and start on the first row of
flowers in the front. Combine blue and magenta, dropping
in violet to brighten the mix. Paint the next row with more
blue, leaving the remaining rows increasingly less detailed
as they recede into bluish-violet.

STEP 4

Paint the last row of mountains with watery blue, burnt sienna, and a little violet. Use a darker version of that mixture for the closer row of mountains. Then paint the foreground around the flowers yellow and green.

Brighten the trees with yellow and the sunset with more layers of the same sky colors from before. Fill in the land area with more yellow and green. For the grass and stems, use a liner or rigger brush to create thin lines with olive green, and add light green and yellow for interest.

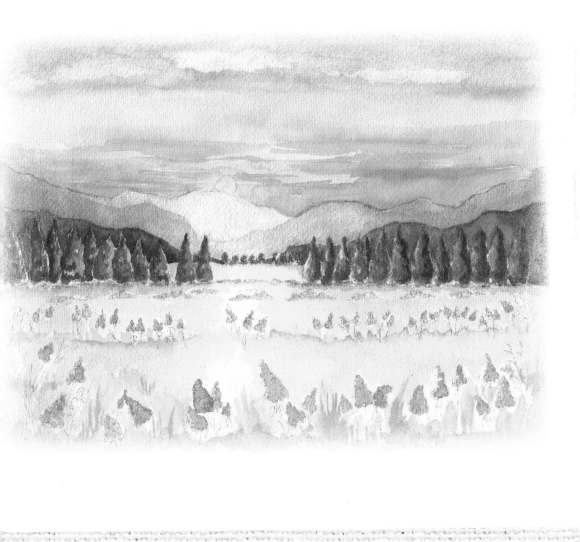

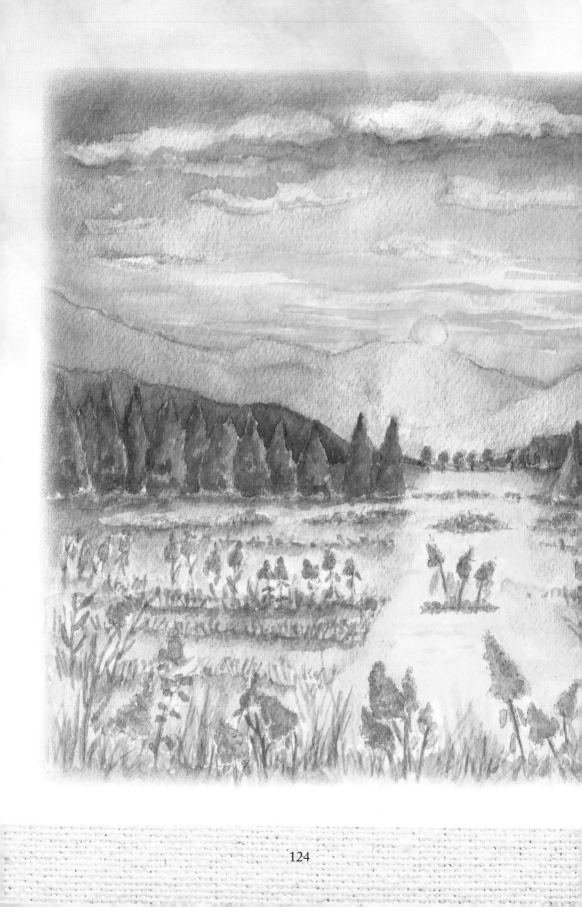

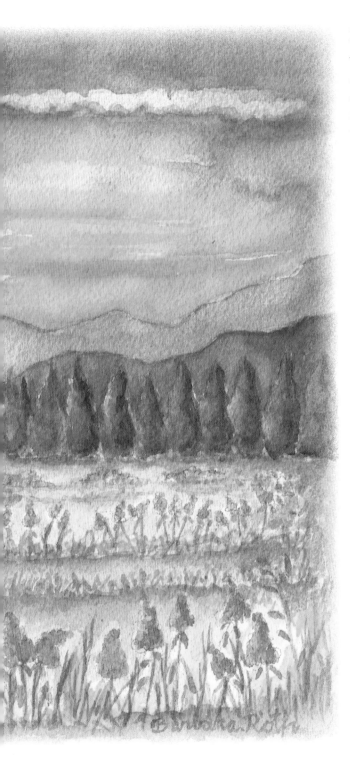

STEP 5

When the trees are dry, glaze over them with a watery wash of sienna to unify their look and make them appear to recede into the distance. Darken the top of the sky with more blue and violet to emphasize the drama of the sky. Add dark green and blue to the foliage in the front.

REMEMBER: IT'S NEVER TOO LATE TO GO BACK AND CHANGE SOMETHING YOU DON'T LIKE!

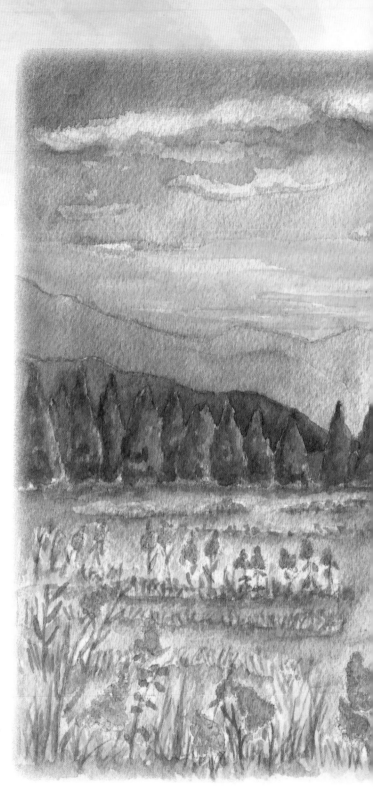

STEP 6

Review the finished painting from a distance. If you decide you dislike the path of light (as I did), combine more burnt sienna with a touch of magenta to cover most of the middle of the painting.

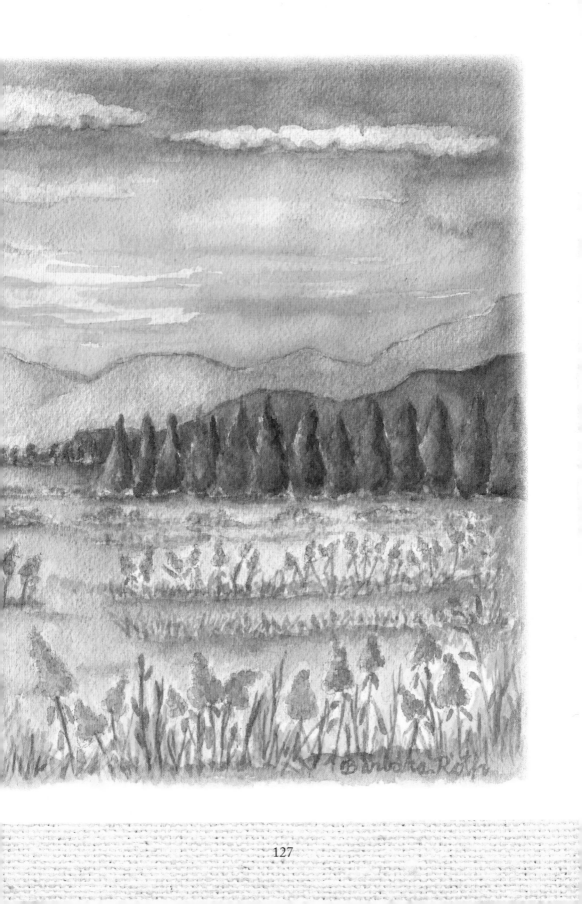

About the Author

Barbara Roth lives in San Diego, where she teaches art and paints in her home studio as well as anywhere around the house. With a degree in art and a teaching credential in art education, she has taught art to students ranging from ages 2 to 92. She firmly believes that anyone can draw and paint if they learn basic art skills, are willing to tolerate their imperfect attempts, and will do their homework.

Barbara's art career began at 3 years old, when she received her first box of crayons. Since then, she has explored many paths as an artist, including middle school art teacher, children's book writer and illustrator, pet portraiture painter, dancewear designer, and furniture painter. She eventually discovered her true love of art a decade ago when she combined traveling, journaling, and watercolor to start making anywhere, anytime art. Since then, she has carried a sketchbook with her everywhere from her backyard to a mountaintop in southern France.

Barbara teaches art in her hometown as well as around the United States and Europe with her art-tour company, Anywhere Art LLC.

For Rick and Sarah, who supply me with love and laughter.